CU00797583

Truth, Beauty, and the Common Good

# INTERDISCIPLINARY STUDIES IN PERFORMANCE
## HISTORICAL NARRATIVES. THEATER. PUBLIC LIFE

Edited by Mirosław Kocur

## Volume 28

**PETER LANG**

Christopher Garbowski

# Truth, Beauty, and the Common Good

The Search for Meaning through Culture, Community and Life

PETER LANG

**Bibliographic Information published by the Deutsche Nationalbibliothek**
The Deutsche Nationalbibliothek lists this publication in the Deutsche
Nationalbibliografie; detailed bibliographic data is available in the internet at
http://dnb.d-nb.de.

**Library of Congress Cataloging-in-Publication Data**
A CIP catalog record for this book has been applied for at the
Library of Congress.

This publication was financially supported by Maria Curie-Skłodowska University.

Cover illustration: A photo of the Holy Trinity Chapel in Lublin, printed with the
kind permission of the Lublin Museum. This photo was taken by Piotr Maciuk.

ISSN 2364-3919
ISBN 978-3-631-86421-0 (Print)
E-ISBN 978-3-631-86927-7 (E-PDF)
E-ISBN 978-3-631-86944-4 (EPUB)
DOI 10.3726/b19177

© Peter Lang GmbH
Internationaler Verlag der Wissenschaften
Berlin 2021
All rights reserved.

Peter Lang – Berlin · Bern · Bruxelles · New York · Oxford · Warszawa · Wien

This publication has been peer reviewed.

www.peterlang.com

# Contents

# Acknowledgements

A number of years ago I co-organized a conference on Charles Taylor's philosophy which broached the topic of its applicability for the humanities. Since then, having taught a philosophy and popular culture course for the last several years at my university, I have felt the need for some time for using a more philosophical approach to several problems that interest me, especially since it seems to me other approaches in academic research—including the ones I used—do not nearly as well plumb the potential of the humanities that are largely stuck in the "knowledge factory" mode, and not just in Poland where I teach. This book does not fully accomplish my aim, but it is certainly closer to what I wish to accomplish. And certainly the topic I chose gives me space for development.

The actual idea for tackling the transcendentals in this book came from two articles I published in the online journal *The New English Review*. The first of these articles was: "The Wedding of High Art and Popular Culture: Beauty that 'Will Save the World' and 'Which Upon Being Seen Pleases,'" and was published in the September 2020 number of the journal. The second article was "To See the World in a Grain of Sand: The Family, the National Community and the Common Good," published the following month. Both articles have been incorporated into the first two chapters of this book—with more or less editing—and with the permission of the editors of *The New English Review*. I am very grateful to the editors for the encouragement they gave me both for the original articles and for this project.

Moreover, realizing the importance of religion for community and the common good drew me to my earlier writing on religion in Poland, most specifically the article "Catholicism in the New Poland: A Religion and Society in Transition," which was published the fifth number of the online journal Occasional Papers on Religion in Eastern Europe in 2020. While I hold the copyright on the article I do wish to acknowledge the previous publication of the portion of the article that I use in this book.

I also wish to thank the people at Muzeum Narodowe w Lublinie for allowing me to use the photograph of the Holy Trinity chapel for the cover of the book.

# Introduction

I was already living in Poland for a number of years when the Winter Olympics of 2002 were held in Salt Lake City. At a symbolic level my past and present were represented during the opening ceremonies of the games. First, an honorary position was given to the Polish Nobel peace prize winner Lech Walesa, who helped carry the Olympic flag during the parade early in the ceremonies, together with— among other people—another laureate, Bishop Desmond Tutu. This stirred the hearts of many like myself watching the ceremonies in Poland. Second, just a little later when the slightly less symbolic and more entertaining part of the ceremonies took place, on the theme of Native Americans, the Canadian musician Robbie Robertson—formerly of the legendary rock group The Band, after which he had been exploring his Native American identity—was leading a band that was now performing at the ceremonies. Since I am from Canada myself and had been a great fan of The Band and was now a Polish citizen as well, at the time the combined presence of the historical leader of the Solidarity Trade Union and a great Canadian artist—even if he also had American citizenship at this point—at the ceremonies struck a deep chord within me.

One of the differences between living in Poland and Canada was the mobility of life in the latter. I came to Poland in the first half of the 1980s to study at the Catholic University of Lublin and am still in the city decades later, whereas while in Canada, especially after graduating from community college, I moved around to different places of employment. But during my last years in my hometown in the 1970s I would regularly watch *Man Alive* on television, an excellent Canadian public program on religion. The title came from a saying attributed to the second century Church Father St. Irenaeus: "The glory of God is man fully alive." In this self-explanatory aphorism we find the basis of Christian humanism, developed more fully later among others by St Augustine and St Thomas Aquinas. One of the programs I will never forget is when the Jewish psychiatrist and survivor of German concentration camps Viktor E. Frankl was interviewed. My father was a Polish war veteran, for one thing, so his story was closer to me since it concerned the war, the memories of which had accompanied my childhood. But at one point after the program my Polish Canadian mother gave me letters from a member of her family describing how he had survived the gulags in the Soviet Union where he had been imprisoned during the war, like so many Poles. When I read those letters, they made what Frankl wrote about his experiences in concentration camps—once I started reading his *Man's Search for Meaning*,

which starts with his memoir and reflections on the experience before his sys-
temized theory—even closer for me. This also helped me better understand what
my uncle I never met had gone through and how he did not lose hope and man-
aged to survive. So from early on Frankl's thought had something of a personal
meaning for me.

What I gained from all this is something along the lines of Einstein's idea that
a theory must have elegance, in other words some aesthetic quality that allows it
lodge in your mind. This to no small extent was the result of the combination of
his dramatic real-life experiences that complimented his theory, making it seem
so true to life while corresponding with my closer knowledge at the time. My
family history certainly provided a deeper affinity for me with regards to Frankl,
and this is partly why he remains so pertinent to me after so many years.

The essence of Frankl's psychology is the crucial need for meaning in our
lives; he called it the will to meaning. He integrated this form of motivation in
our lives with what was earlier discerned by Freud and Adler, that is he accepted
that we are also governed by instincts and a will to power. He did not reject what
he felt was constructive in his Viennese predecessors' theories. Yes, instincts are
important, and power even had a positive role in our lives, for instance the power
parents had in the surrounding world could help a child feel secure and thus
played a role in his or her development. Nevertheless, for Frankl it was finding
meaning that made our lives truly human—it could be said that it helped us be
truly alive in a manner similar to St. Irenaeus' understanding. Only when we
could not find meaning did the lower levels of our being—power and instincts—
fill the void, so to speak, and in doing so become distorted. In Frankl's theory
meaning allowed us to transcend ourselves. Thus, he laid the foundations of what
later developed as moral or positive psychology.

Frankl is surprisingly confident in human nature. Freud once claimed in ac-
cordance with his theory that when people are starving, they are all the same,
reduced virtually to the level of animals. Naturally the difficulty with such a
claim is that it is impossible to test under normal conditions. Who in the com-
fortable West could honestly say they know how they would behave under such
a circumstance. History, however, conducts such experiments. Having experi-
enced German concentration camps Frankl knew that people responded differ-
ently. Some indeed were reduced in the manner that Freud described, but he saw
that others transcended their state, for instance sharing what little food they had
with those who were in even greater need. To no small degree he noted it was the
decisions people made together with their attitude that made a difference. And
Frankl saw that religion was not "the opium of the masses," and could genuinely
help people under such circumstances.

According to Frankl, meaning is found in values, in family and religion, among other places. It is not hard to extrapolate from that that meaning can be found in the transcendentals—truth, beauty and the good—which can be called values, or rather meta values. And so, in Frankl's psychology they lead us to transcend ourselves. But there is more in the theory that interests me,

For one thing, when Frankl insists that meaning is found, this means that it is not constructed, and that is fairly clear in his theory. And so, from this perspective values such as the transcendentals are also real, and thus they help make us fully human. This also implies there is a kinship to one thing that has long been thought to be found, or rather discovered, and gives our lives direction, that is our vocation. A vocation, however, is a calling. And while in contrast a career is indeed constructed, in other words we pursue and make it, a calling has to come from somewhere—but from where?

Obviously, a calling would not be a calling if it did not come from outside of ourselves. For the religious person the answer of where it comes from is obvious: our vocation comes from a personal God, which does not exclude the necessity of great spiritual and moral effort on the part of the seeker. In as much as the transcendentals can be seen as part of our vocation, something to live up to or discover, they can be seen a part of what makes us "fully alive:" both for our benefit and for the glory of our Creator.

For the irreligious or perhaps religiously indifferent, vocation when it is felt also comes from outside the self. In V.S. Naipaul's lecture "Our Universal Civilization," delivered at the Manhattan Institute in 1990, the writer insisted his specific vocation to write came from Western civilization and the values it instilled, values that he claimed were missing in his Indian upbringing at home. Among these values he so treasured was the pursuit of happiness, which he saw in broader terms: "So much is contained in it: the idea of the individual, responsibility, choice, the life of the intellect, the idea of vocation and perfectibility and achievement. It is an immense human idea."[1] The idea of the relationship between vocation and happiness is worth stressing, since the latter also suggests certain deep, religious cultural roots. It's worth recalling that no less an authority than St. Augustine proclaimed: "All wish to be happy; none will be so but those who wish to be good."[2] Thus a morally vigorous pursuit of happiness is not the oxymoron it seems to be, and Naipaul was implicitly aware of this, understanding the golden rule as particularly inspiring.

But there is a contemporary way of thinking that is even closer to the transcendentals in the values it expounds: the return of virtue ethics late in the twentieth century. The philosopher responsible for this was Alisdair MacIntyre with his seminal work *After Virtue* of 1981. As what is now a major branch of moral

philosophy virtue ethics has undertaken a great number of questions. For the
purposes of my book in which popular culture will be drawn upon often enough
the version that the philosopher Joseph Kupfer synthesizes in his *Visions of Virtue
in Popular Film* of 1999 is most useful. The virtues can be divided into those Ar-
istotle forwarded: intellectual, moral, and aesthetic. You cannot get much closer
to truth, beauty, and goodness than that. Put in traditional terms, through per-
fecting ourselves under their guidance we are on the road to attaining the Ar-
istotelian good life—of which happiness was a crucial part, it might be added.
In his book *Truth, Beauty, and Goodness Reframed* from 2011 educator Howard
Gardner makes a parallel connection of the transcendentals as virtues, which are
derived from classical virtues. Basically, in the context of virtue ethics the tran-
scendentals serve a purpose, that is have a *telos*. This ties the transcendentals to
educational philosophy through demonstrating their continued relevance in the
field of human development.

   And so if we look at these four primary aspects of the transcendentals that
concern me: becoming "fully alive" in the perspective of Christian humanism,
transcending ourselves in moral psychology, fulfilling our vocation in life and
perfecting ourselves to attain the good life, there are certainly differences, but
they are nevertheless complimentary. All of them require an effort with a goal, a
search—a journey, in other words—that leads to meaning. My intention in this
essay is to explore each of the transcendentals—truth, beauty, and the good—
largely from these perspectives. The effects of this exploration can also be con-
sidered my contribution to what in broader terms could be called a philosophy
of culture, which also implicitly affects a philosophy of education that supports
the liberal arts, so important to me as an educator.

   My own vocation, providentially discovered in Poland after studying its cul-
ture and religion, was to make use of my background in Canada to teach Amer-
ican culture—primarily through film—to Polish university students, and to
mediate Polish culture at various levels, primarily academic, to cultural tourists
or student foreigners, and sometimes readers. In a sense my intention to look
at the transcendentals in this essay will integrate this vocation of mine to give
my reflections a more personal perspective. I have had an academic interest in
the transcendentals, sometimes open, more often implicit, in my examination of
axiology in narrative art—film and literature—from the beginning of my work
at a university. However, in the question of truth I will move beyond pure aca-
demia to a broader, simultaneous more strictly humanistic and also of a some-
what more personal exploration, that is partially based on life experience and
observation. I will do so in no small degree because, as Richard Cocks aptly
puts it, "Some truths are accessible only to a normally thinking, feeling, person."

These truths govern our actions, and "actions are a better indication of actual beliefs than words."[3] Put simply, when they are discerned in our surroundings and actions they give us meaning.

At a more profound level among the more ambitious recent studies of the transcendentals a theological approach has appeared that also brings the medieval roots of the discussion to our attention with related suggestions probing for their current appropriateness. Alice Ramos's foray into the fecund field resulted in her book *Dynamic Transcendentals: Truth, Goodness and Beauty from a Thomistic Perspective*, which penetrates the fields of anthropology, ethics and metaphysics.[4]

Where does this leave the personal aspect? The "personal" in this journey of mine through the transcendentals is also at least in part philosophically "personalist." Here again I tap into a broad Christian humanism. Personalism is a philosophical stance that is neither individualistic nor collectivist, and thus it is partly communitarian. Among other reasons, on account of this perspective when I examine the good I will rather focus on the common good. Robert Royal explains that personalism draws on biblical notions, for instance *imago Dei*— that we are created in the image and likeness of God—as well as Enlightenment ideas of human dignity. Closer to the present, according to Royal, representatives of the notion such as Martin Buber countered reductionist views of the person, simultaneously stressing the importance of encountering the other, while for Emmanuel Levinas, "the way of the Law for human beings calls communities … into existence and constitutes them before and beyond any duties to the state."[5] From the political perspective personalism forwards subsidiarity that limits the intrusiveness of the state.

It might also be noted the thinkers Royal draws upon whom I have cited are known as dialogical thinkers. Dialogue seems to have declined as a form of enquiry. I would propose that it is inherent, among others, in moral psychology, especially as presented by Frankl, which informs my approach.

Returning to the Salt Lake City Olympic Games, from the perspective of the transcendentals we view Walesa as a political activist who had worked for the common good of the Polish national community against a totalitarian system governed by falsehood, in other words the good in his actions needed to be related to truth. Robbie Robertson, on the other hand, as a musician brought beauty to many people, and we will look at a specific element of this in the first chapter. Let us linger on the question of beauty and its implication for yet a while.

Looking at the Olympic games in general it is worth recalling that alongside beauty found in art it is also found in sport, as we are not infrequently reminded in motion pictures. *Chariots of Fire* of 1984 is likely the best example of a sports

film from this perspective centered on the Olympic games themselves. In some sports beauty is evident enough without the additional art of the cinematic camera. In the summer games gymnastics are particularly dynamic and yet graceful, while their counterpart in the winter games might be figure skating. At the games in Salt Lake City there was a Polish athlete that competed in a particularly beautiful sport. Adam Małysz was a superb ski jumper, an exceptionally graceful sport. In the relationship between sport and beauty a certain dynamic relationship exists between the fact of someone rooting for a competitor and the inherent beauty of that sport. The inherent beauty is independent of the fact of the competition, but it is discovered by the viewer when there is a motivation to pay closer attention to the sport, such as when a competitor is important to you for some reason. In the Olympic games this is often the case when he or she represents your national community. And Małysz brought that beauty home for a good many Poles, including myself.

There is the archetypical human dream of flight that the athletes in ski jumping elicit. And few humans can fly as these athletes do—more accurately soar—so far with so little support in the air; the result of a couple of streamlined flat boards attached to the athletes' feet that along with their bodies they must position in just the right way after springing from the sloped runway that propels them upward for a time and with the help of air currents leads to a serene descent. And then there follows their graceful landing. Of course this is a sport, so every pertinent element is measured and points are appointed accordingly. Most of the points are for the distance covered in the jump, but not a few points are accorded for the gracefulness of the landing, no doubt in part a safety measure: the beauty of the sport sometimes takes the awareness of the spectator off its danger. After winning the world cup for the sport three seasons in a row, thus tying a world record, Małysz suffered an injury from a fall in the subsequent season, which cut it short for him. Fortunately he was able to return the following season, but some ski jumpers are not so lucky.

But there is more to Adam Małysz than just his success at a wonderful sport and bringing a particular perception of beauty closer to his fellow Poles, as well as many others. Through his efforts and the excellence he attained that were profusely rewarded internationally he became a national hero. At the time, a little over a decade after the regaining of a sovereign state by the country after the fortunately peaceful collapse of communism together with the painful transition from a centralized command economy to a free market one, heroes helped ease the frustration and pain many Poles were experiencing. Thus he was the source of a necessary and much needed good. But he extended that good even more so on account of pointing out the beauty of the sport for the fans in a manner

that overcame their narrow views of sport and competition. After his success on the international stage one of the ski jumping events in Poland that awarded points toward the world cup unsurprisingly became besieged by throngs of Polish fans. During one of these events at the resort town Zakopane a ski jumper from another country gained more points for his jumps than the national hero and the fans started booing. Małysz chastised these Polish fans for their behavior, pointing out the beauty of the sport and that every jump should be seen in this light. In other words, although he was grateful for their support, he taught them a lesson in appreciating the sport for its inherent qualities and to appreciate the other competitors when their jumps showed excellence. Somewhat surprisingly, the fans listened and the future events became more joyful. In this manner the national hero made an exceptional contribution to the common good of his national community.

In his own take on the transcendentals, Gardner argues that despite the accelerated pace of our times these values remain a cornerstone of our society. As he eloquently puts it, "if we give up lives marked by truth, beauty, and goodness—or at least the perennial quest for them—to all intents and purposes we resign ourselves to a world where nothing is of value, where anything goes."[6] His book also comes down forcefully on the side of human agency.

Gardner and Ramos wrote their books a good decade ago. The transcendentals have not received the treatment they deserve which is not to say the gauntlet has not been picked up since then in various forms in books and other forums, but it is nevertheless time for another visit and from a somewhat different perspective. One might also note that with the decline of the humanities in universities in much of the West,[7] it can be argued the time has come to bring the transcendendals to the fore to a greater degree. That is not my only concern, however. Despite the erudition and sensitivity to nuances and distinctions Gardner's version largely reflects American society. Although that perspective partly informs my own, my experience also leads me to explore a quite different world, more specifically the Polish one and its broader—largely European—context; in both of these worlds the transcendentals nevertheless help in find meaning.

The common linguistic order of the transcendentals that has virtually entered the vernacular is truth, followed by beauty and then goodness. I follow this order in my title but in my essay itself I will start from beauty, and then move on to goodness—or rather the common good—both of which will be treated in a somewhat more academic manner, while truth will be discussed at the end, and will indeed be somewhat more personal in almost the vernacular understanding. Moreover, the book will engage in an exploration of the philosophy of religion

and culture which at key points in the discussion will draw upon ritual, works of high and especially popular culture—particularly film.

# Chapter 1 Between High Art and Popular Culture: Beauty Where Art Thou?

In Guido Mina di Sospiro's thought provoking essay "How the Most Musical Century in the History of Western Civilization Came About" the author provides an account of how the abandonment of beauty in musical high art in the previous century facilitated the creation of a number of popular forms of music. The problem is not so much the popular forms as the state of the higher form. A partial explanation is given for the failure of much of contemporary classical music to appeal to most people through its voluntary descent into ugliness that was rationalized, among others, by Theodor Adorno's polemic against beauty. The philosopher argued that focusing on beauty supported capitalism by making it aesthetically pleasing. And so, the author notes, for the Adorno: "Ugliness… was to be reproduced in the new language of avant-garde music, and art in general."[1] This musical phenomenon could hardly meet the need that most people have for music that could be listened to—not to mention art to be enjoyed—so a number of other forms of music gratified that need, most notably jazz and rock.

Di Sospiro's description of this state of affairs raises the question of how it came about within the broader context of art; moreover, whether there is hope for any reversal of the situation is also worth further reflection. However, the deflection of beauty to popular culture and the relationship of the latter to high art that he indirectly touches upon is particularly worthy of consideration for me. And although through it all I am interested in the classical axiological concern connected with beauty that adds to its understanding, that is beauty understood as a transcendental, I also wish to bring this classical concern more down to earth, literally closer to home toward the end, and explore how it affects our lives. One might put it as what is the role of beauty in the good life but also in our search for meaning.

Sticking to art for now, in the history of world art it is not unprecedented for popular culture to demonstrate a vitality lacking in the art of higher spheres of a given society. One merely has to think of the superb works of the Japanese masters of the *ukiyo-e*—such as Hiroshige, Hokusai, or Sharaku, to mention a few—and their woodblock prints virtually mass produced for the middle-class, of which Hokusai's "Great Wave Off Kanagawa" is merely the most iconic, in contrast to the forgotten work of the high art masters of the same period that painted

for the nation's aristocratic upper class. Moreover, at times popular forms in due course rose to high levels in the West: the novel is a primary example; motion pictures are another. And the latter pertains not only to the international art house cinema with its undoubted artistic successes, but also Hollywood cinema, with the heights it reached, for instance, in the best works of John Ford and others of a slightly lesser stature—as one might put it a true wedding of high art and popular culture.

What this also demonstrates is the restlessness in humanity's overall artistic enterprise: especially but not exclusively at its Western end. Heights are reached followed by slower or more rapid descents, which in part explains the phenomenon presented so provocatively by di Sospiro on the example of Western music of the twentieth century. And at times there are partial recoveries. For some time now beauty has indeed been largely abandoned or diminished, both in music and the visual fine arts—Arthur Danto's *After the End of Art* (1997) argues the latter issue while Swedish director Ruben Ostlund cleverly deconstructs the pretentions of the artistic milieu in *The Square* (2017). I live in Poland and fortunately there still are young artists from art schools who aim for beauty in their art, but there are also those involved in the high art scene that recognize some of the absurdities from Ostlund's film as in principle hitting the mark.

Conversely, beauty is sought by most people wherever they can find it. A clever Czech car commercial on Polish television from the beginning of the present century capitalized on this dissonance. A young couple attend an opening night at a gallery featuring an ugly conceptual art exhibition. Many in attendance are in real or feigned awe of the "art" on display, not always certain what it signifies. The young couple are bemused. When they decide to leave they have some trouble at the coat rack with their garments: opening night guests crowding around it are uncertain as to whether or not the rack is part of the exhibition. The couple make their way through the throng, take their coats and leave. Outside the couple are comforted by true beauty: the pleasing design of their new Skoda, a Czech car. In part this commercial proves Adorno's argument, but it primarily demonstrates a human reaction to the state of high art he helped perpetuate: if there is a dearth of beauty on high it is gladly accepted in a lower form, like, for instance, jazz or rock.

The above commercial also illustrates, at something of a remove, an aspect of beauty Martha Bayles argues is at the base of the rise of one of the outstanding forms of the musical arts of the twentieth century, the blues. "For more than a century," the critic argues, "the blues performer's motto has not been 'art for art's sake' but 'make way for the paying customer.'"[2] And paradoxically or not this contributed to the vitality of the form. Frank Capra, who at least some scholars

acknowledge as a filmmaker auteur, expressed a similar sentiment in his auto-biography *The Name Above the Title* (1971), where he relates that when he was making his films in the 1930s filmmakers had various visions of their art but it was the viewers who voted for them by purchasing tickets. In democratic art forms the customers—i.e. consumers—are the patrons.

What can we say about these patrons? Are they any worse than the usually aristocratic patrons of the past? I wish to relate this question to the axiological problem of beauty as a transcendental. One of the strongest statements along this line is by Fyodor Dostoevsky and his oft cited, near aphoristic statement: "Beauty will save the world." Of course much depends how the claim is understood. After his experiences in World War II and communist Gulags, Aleksandr Solzhenitsyn initially was skeptical that any possible truth could be contained within it, but eventually acknowledged its prophetic insights. Russian philosopher Vladimir Soloviev attributes the statement, actually a line from a character in *The Idiot*, directly to the author with beauty as a transcendental. "The infinity of the human soul—having been revealed in Christ and capable of fitting into itself all the boundlessness of divinity—is at one and the same time both the greatest good, the highest truth, and the most perfect beauty," he insists, concluding:

> Truth is good, perceived by the human mind; beauty is the same good and the same truth, corporeally embodied in solid living form. And its full embodiment—the end, the goal, and the perfection—already exists in everything, and this is why Dostoevsky said that beauty will save the world.[3]

Having attended a number of Orthodox liturgies, where beauty is such an up-lifting element of the experience, this argument is especially close to me. I often think of Dostoevsky at such moments. A particularly powerful expression of this is Andrei Rublev's icon *Holy Trinity*, which arguably brings this transcendental aspect of high art to the fore. In one of his comments on the eponymous hero of his film *Andrei Rublev* of 1966 the filmmaker Andrei Tarkovsky called icons a prayer.

In a somewhat similar manner Nikolai Berdyaev, another Russian philosopher from the first half of the twentieth century, felt that products of the human imagination such art and music and so on are expressions of a spiritual reality and the interior life of their creators. He also believed beauty had a relationship with truth and goodness. Consequently, as Richard Cocks conveys his thought, in complete contrast to Adorno: "Ugly art, music, and architecture says something negative about the people who made them."[4] And obviously there is practically nothing spiritual about them.

But there is one more thing we should note about the art of Dostoevsky. Besides being profound his novels are deeply enthralling—he is a master storyteller. We might say that the beauty he creates is also entertaining. Here it is worth looking at how the beauty of art is open to a more popular perception. A twentieth century philosopher who devoted much thought to the relationship of beauty and art is Jacques Maritain. He argued the general end of art is beauty. Since art is a creative activity and is dependent on the creator, the beauty it aspires to is also in a relationship to the divine as well as to the transcendentals of goodness, truth and unity. If this were all it would be close to Dostoevsky in Soloviev's reading. However, in his seminal *Art and Scholasticism* (1920) Maritain also claims the beauty that is the proper end of both artisans and artists is "that which upon being seen pleases."[5]

It hardly needs stressing that this pleasure is not simply related to the pleasure principle. Otherwise its relationship to the transcendentals makes little sense. For one thing, Maritain stresses the intellectual nature of the pleasure evoked by art. On a broader level, however, what is implicit in this understanding of beauty is its relationship to the good life, that is the ethical nature of happiness when it is attained through the virtues. But as the American founding fathers intuited, happiness must be pursued: it does not come on its own. And this is witnessed in the history of Western art. The restless pursuit of happiness through beauty in the arts partly explains the myriad styles that were developed over the ages.

We might also compare Leonardo da Vinci's *Last Supper* to Rublev's *Holy Trinity*. Here we have a religious work that makes a tremendous effort to reach out to the viewers through its visualized narrative drama and is rewarded by the enormous popularity of the work that it has maintained over a number of centuries, often among "ordinary" viewers and through commercial and home spun copies. That outreach is a frequent characteristic of Western art, and as the patron or "consumer" changed so did the artist and the art form.

It should be remembered, however, change has not removed the art of masters from our reach. Art historian Julian Spalding puts it succinctly, "Phidias, Leonardo and Picasso had eyes, hearts and brains just like ours; they had brilliant minds, it's true, but we can go a long way to understanding their art by using our own eyes, hearts, and minds."[6] Often enough it takes an imaginative leap to enter into the sensibilities of another epoch. In appreciating art, however, it helps to retain a sense of wonder, which has inspired art and most human endeavors. But it is a human quality somewhat in decline in our more jaded times. Can it be recovered? That is the question that concerns Spalding and it certainly is a crucial one.

Worth adding, for contemporary viewers and audiences it still seems necessary to include the virtues in art in order to provide a convincing depiction of the

successful pursuit of happiness, even in motion pictures. Similarly, in *The Pleasures of Virtue* (1995) Anne Crippen Rudderman persuasively argues happiness in the novels of Jane Austen is grounded in the virtues in a manner that would make Aristotle proud. My hunch, in turn, is that the excellence of a number of Hollywood romantic comedies from *It Happened One Night* (1934) right on up to Nora Ephron is in part a legacy of the impact of Austen on the genre, however indirect. More clearly, the initially hedonistic protagonist of the romantic fantasy *Groundhog Day* (1993), from the depths of despair that his essentially nihilistic lifestyle lowered him to, transcends his self-centered narcissism to develop aesthetic, intellectual and moral virtues to win his beloved.[7]

Each case of an art form has its own history, its own rise and fall. Looking more closely at rock music, for instance, it can be said the art form reached its acme in the 1970s after which it declined and other popular forms of music caught the attention of the young. But this creative culminating point was not quite progressive rock, as di Sospiro for one suggests, but its refined version rooted in the blues and even religion.[8] Let's look briefly first at a couple of milestones that chart the rollercoaster of this popular form.

No doubt the outstanding musical team in rock was that of John Lennon and Paul McCartney probably most fully demonstrated in *St. Pepper's Lonely Hearts Club Band* of 1967. Musicologist Walter Everett summarizes the overall importance of the work:

> The rock world has known albums of serious artistry by Yes and Pink Floyd, of recreational value by Michael Jackson and the B-52s, and of influence by the Sex Pistols and Nirvana, but no object in its entire history can match the immediacy and power with which a collection of songs exemplifies all of these aspects so intensely and above and beyond its fellows as *St. Pepper's Lonely Hearts Club Band*.[9]

Along these lines it seems to me one of the keys to their musical genius was a dynamic combination of authenticity and playfulness probably most successfully wedded in the title song of the *St. Pepper's*. But what about when one or the other qualities of authenticity or playfulness unsurprisingly took the fore in some songs? Lennon was the strongest at bringing across a feeling of authenticity, as for instance he does quite forcefully in his song "Help" of 1965. Conversely, McCartney was the master of playfulness, which he demonstrated among others in "Lovely Rita" in *St. Pepper's*. Listening to these songs today Lennon's song is undoubtedly effective, but to a greater extent trapped in its time. It hits hard, grabs you, and then sags: something is missing. On the other hand "Lovely Rita," while the song certainly reflects its time—virtually all art does—it also transcends it.

This might seem odd, since more or less at the time of its release for most people it probably seemed a playful but quite light and ultimately forgettable ditty.

Some hint at the issue here is suggested by philosopher of culture Byung-Chuk Han who finds a substantial problem with the ethos of authenticity that has been recognized as a key to our current culture. According to Han the ethos has an essentially narcissistic base. What's more, on account of the narcissistic cult of authenticity even the arts have become increasingly profane and disenchanted, losing their playful nature through focusing on form and content. Thus, Han claims, "The disenchantment of art is a symptom of narcissism, of narcissistic internalization."[10] Perhaps the point is overstated, but it is not without substance. Every good has its shadow, one might say, and not all was well with the authenticity of the 1960s and 1970s. Through McCartney's merging of rhythm and blues with the English Music Hall tradition he maintained a playfulness in his interpretation of the rock tradition, keeping it fresh in a manner his overly political partner does not in his piece. It might be added Lennon was apparently not too thrilled with the inclusion of "Lovely Rita" in such an ambitious album. The irony here might be that while authenticity and its failings drive the song "Help," the Beatles movie of 1965 which used the title and the song itself is quite playful.

It's also been noted that in some of their songs the Beatles were capable of expressing a higher love. But in his *Love Songs: The Hidden History* (2015) Ted Gioia notes it is especially the period between 1970 and 1975 that produced a string of singer-songwriter capable of a lyrical and poetic rock that stood out in the popular music of the period. Significantly, artists like Joni Mitchell, Van Morrison, Carole King and Carly Simon, among others, frequently with their own individual quirks, often concentrated on romantic love.

The above musical bright spot makes it all the more unfortunate that one of the aesthetic paths chosen by rock, also connected with the times it reflected and co-created, was its obsession with sex. Rock even misinterpreted the stoicism inherent in African American music for this end, as Bayles convincingly argues.[11] One can only wonder how the overall musical form would have developed without this.

Coming to the question of religion in rock, it's worth recalling a film that encapsulates the history of rock and roll, especially its roots. During the course of its humorous narrative the popular cult film *The Blues Bothers* of 1980 frames rock and its roots between the Gospel number "The Old Landmark" performed by James Brown and the James Cleveland Choir and the eponymous Blues Brothers' version of "Jailhouse Rock," made famous by Elvis Presley. The history is augmented by a number of classic blues and soul numbers delivered by some

of the most outstanding artists of their respective musical modes. In Brown's number, the great soul artist reprises the "Devil destroying" routines—including "hard singing," "shouting, keening, moaning, screaming, and exhortation"[12]— of his musical mentor Ira Tucker, which in his career Brown had partially incorporated into his secular style: thus demonstrating the religion that inspired rock among some of its early artists. Artists such as Sister Rosetta Tharpe, Elvis Presley, Little Richard, Jerry Lee Lewis and Johnny Cash all shared Pentecostal or similar Church of holiness roots.

Worth adding here, among the performances of *The Blues Brothers* was one by the incomparable soul artist Aretha Franklin. Soul is of course another popular musical form that had roots in religious music, as we have been fortunate enough to be reminded recently by the long delayed documentary film release of *Amazing Grace* in 2019 of Franklin's concert and album recording in 1972 at the New Temple Missionary Baptist Church in Los Angeles. The contrast between the vivacious rendition of her version of "Think" in the John Landis film and the humble performer delivering the heart-rending spiritual sounds of Gospel in *Amazing Grace* shows her astounding range. While the poignant beauty of her performance of "Amazing Grace" indeed seems to delve into the profound source of what can save the world.

Fast forward to the peak of rock. A symbolic event took place on November 25, 1976, when, assisted by a number of musical friends, the five man rock ensemble known as The Band bid their public farewell in a concert billed 'The Last Waltz.' Martin Scorsese's subsequent "rockumentary," also entitled *The Last Waltz* (1978), a cultural artefact that arose in the concert's wake,[13] has turned out to be even more memorable. Much the same as *The Blues Brothers*, Scorsese's film rehearses the history of rock, from the blues, to rockabilly, and so on, with the help of a wonderful range of guests to augment the reprisal of The Band's own contribution to rock.

Significantly, an important song from a memorable musical event helps demonstrate the connection between religion and rock at its height. The film captures the inspired rendition of The Band's classic "The Weight," with the vocal support of the superlative Gospel group the Staples. The Gospel group did not have to depart from their métier to any great degree in their stirring contribution to this rock song's performance, almost appropriating it from The Band, and demonstrating its debt to their spiritual musical tradition. Deeply moved by the effort and its poignant result one of the vocalists from the Staples at the very end of "The Weight" exclaims: "Beautiful!"[14] I would argue the beauty the artist intuited captured beauty in alignment both with truth and goodness as well as delight, wedding high art and popular culture to the highest degree.

But sadly with a few exceptions this high point with love and religion was not developed further in rock. Arguably, there were a few such moments in disco, given their due by that subtle cinematic master, Whit Stillman in his *Last Days of Disco* (1998).

At least one more thing can be said of the outreach for beauty in terms of a dialogue between high and popular art forms in line with the above argumentation. The struggle was reframed within film art in its earlier days when the Motion Picture Academy would crown the "serious" films with their most prestigious award, the Oscar for best picture. And the filmmakers themselves would succumb to this interpretation of their work. Among other reasons it was on account of Frank Capra's quest for that coveted award that he made the highly ambitious *Bitter Tea of General Yen* in 1933. But it was through his comparatively light romantic comedy—with a generous helping of genius and a "screwball" touch—*It Happened One Night* of the following year that he finally garnered his first Oscar as director while the film became the first comedy ever to gain the best picture Oscar, and the last comedy for quite some time. Rather the exception that confirmed the rule at the time.

The same context provided the material for political philosopher Mary Nichols' defense of popular culture, when she compared the merits of the "serious" war film *Saving Private Ryan* with the upstart romantic comedy *Shakespeare in Love* that critics complained stole the 1999 Oscar from the Spielberg's effort. Nichols argues John Madden's film rightly earned its award for its philosophical sophistication. She also praises popular culture, which she claims intuits that "the moments of joy enfolded in ordinary life are more profound than those of suffering and despair and that the former redeem the latter, even if it is life's suffering that makes possible the full experience of its joys."[15] Nichols argues that Aristotle himself recommended the common sense that acted as a necessary check on the some of the absurd propositions of "the wise," and that this advice should be remembered on account of the influence of a number of postmodern strains in the late twentieth century. She notes "poetry and philosophy no longer understand their calling," adding optimistically "if Shakespeare is dying in the classroom, he is alive and well in the movie theater." And so here we find a partial answer to the value of the popular culture consumer as patron of the arts. Nichols opts for optimism but does not neglect the dangers. "Popular culture is popular because it resonates with life," she concludes: "At its worst it resonates with the lowest, most vulgar, or most trivial aspects of life, but at its best, it appeals to life's complexity, its nobility, and its wisdom."[16]

In discussing forms of art that combine the high and the popular to a pleasing, at times transcendent beauty, it is important to note that in those times when

the trivial or vulgar seem to dominate we have those recorded artistic moments that pass the test of time—another perhaps banal, but certain means of evaluating the ultimate aesthetic value of beauty, whether or not we attribute to it the meta axiological value of a transcendental. A thing of beauty is "a joy forever," Keats intuited. And like that Grecian urn he praises, often enough the object of beauty—in whatever art form it is captured—combines exquisite craftsmanship and a sublime simplicity that pleases the prince and the pauper, and aids us in attaining a level of self-transcendence: both the human horizontal and, yes, at times the spiritual vertical.

Searching further for the spiritual dimension of beauty, we do well to consider another profound meditation on its potential as a transcendental. In his epic poem *Promethidion* the nineteenth century Polish poet Cyprian Norwid expressed his intuition that "beauty is love." The poem by one of the bards of Romantic poetry in the country is largely forgotten even by most Poles, but the thought on beauty transcends its period and the work in which it was expressed.

If beauty as love for us brings to mind The Beatles "All you need is love," that's a step in the right direction, but it needs certain qualifications. And it should be remembered that despite some artistic highs the love of the 1960s and the 1970s was largely a feel-good phenomenon or overly carnal, which are likely among the reasons why it failed: love must at times be tough, and ready for self-examination. But the latter will mostly be left for a later chapter.

In love the spiritual and the earthly reach out for each other, and beauty surfaces in the most unexpected forms and relationships. For instance, within that most pervasive audio-visual art form of the twentieth century, a good starting point for considering beauty as love in motion pictures is to turn once again to *Shakespeare in Love* discussed by Nichols, where she reflects on the narrative's play within the play and its significance for art and life. "Poetry as such does not move [us], only poetry inspired by life," she insists, adding: "Life as such does not move, only life that can be experienced as poetry, whether or not that life is blessed by a Shakespeare."[17] It should also be remembered Shakespeare himself appealed to various audiences, which is why Hollywood film at its best has been aptly described as a contemporary Shakespearean art that appeals to viewers at different levels. But more important here is the relationship between life and art.

The love song, as Ted Gioia observes, "is the quintessential music for when we let down our guard, leave ourselves defenseless, and accept the experiential richness of our deepest emotional vulnerability."[18] This emotional vulnerability is also elicited in cinematic stories, like in David Lynch's *Straight Story* of 1999, where brotherly rather than romantic love is explored, with a wonderful take on the "comedy of reunion," in one of the slowest road movies imaginable. It is also

a rich ingredient in one of the great love scenes in cinema. In *Groundhog Day*, after experiencing despair in Punxsutawney caused by his own repeatedly selfish hedonistic behavior, Phil Connors finally uses the tactic he has avoided and tells Rita the truth about his condition and genuinely exposes himself to her. This results in her finally attempting to help and comfort him. As they lie together at the end of a long day, and with her head on his shoulder and Rita beginning to slumber, Phil confesses his love for her, ending with a heartfelt: "I don't deserve someone like you… but if I ever could… I swear I would love you… for the rest of my life." In genuine love we feel we do not deserve the other, but this allows us to transcend ourselves. This is one of those experiences of life as poetry, that Nichols rightly insists we need, and the life that fills the art of *Groundhog Day*.

There is also a crucial undercurrent of contrition to Phil's confession, since without her current knowledge he has sinned against Rita among the repeated days of the past by attempting to crudely seduce her. In a genuine confession— whether of sin or love—we expose ourselves, but it is a key to a renewed life. Moreover, his confession witnesses to the truth that we receive love, not make it, which is in essence a biblical notion rejected by the arrogance of modernity, with its belief in "the creation of one's self, by one's self."[19]

What is typical of *Groundhog Day*, however, is this implicit mix of the sacred and profane demonstrated in that act of confession, but present in much of the film. For instance in the honesty it faces up to death, when Phil looks up above in the sky after the elderly vagrant has died, despite his numerous efforts to save him, obviously realizing he is not a "god." Even the holiday, Groundhog Day, has a sacred origin—the second of February is the Feast of Candlemass, also known as the Feast of the Presentation of Jesus Christ, which Germanic immigrants from Europe brought over to the United States together with folk traditions they had associated with the holiday. Obviously the folk traditions took over in the popular imagination and it is a secular holiday in the country, like a number of other previously religious holidays, but the "holy day" at its origin that is "invisible" to most Americans is in some ways analogous to the tough but benign mysterious force that controls Phil's life and leads him to love and renewal. What this symbolizes in the movie is that the sacred that we thought has been left behind can return to aid us in a radically unexpected manner.

Julian Spalding, among others, notes that the majority of the great art in the world is religious. Whether it attains greatness or not, art which is suffused with love often has a spiritual dimension. For a treatment of the spiritual in motion pictures which still reaches a popular audience we do well to turn to the Christmas classic *It's a Wonderful Life* (1946). Frank Capra did not intend his film to be associated with Christmas, but the climax taking place as it does at

that time with its dramatic and uplifting nature made the connection obvious. The earthly dimension of love in the film, also quite strong, ensures that even the irreligious may rejoice at its ultimately straightforward message. As Nancy McDermott notes, the film "manages to deftly skirt the edges of light and dark," and through it all, despite his setbacks that are never actually resolved, she concludes, it is still a wonderful life for George "because he has friends."[20]

The impact of *Wonderful Life* can be subtly felt in a somewhat darker, yet nevertheless uplifting film closer to the end of the last century where what might be called the spiritual dimension, while not so close to the surface, remains a strong undercurrent. In Wayne Wang's *Smoke* of 1993 Christmas is also present at its conclusion—a better term than climax in the looser structure of the work's post-modern narrative. First of all, *Smoke* is an adaptation of Paul Auster's short story "Augie Wren's Christmas Story" that was commissioned from the author by *The New York Times* for the paper's 1990 Christmas edition. Auster also wrote the film's screenplay, although the character of Rashid, the African American boy in search of his father, was created during a brainstorming session with the author and the director. In the film the original short story creates the frame story of the fictional author, playfully named Paul, and Augie, the cigar store clerk in Brooklyn, who offers his "true" Christmas story to the writer that is his customer and friend in his time of need for inspiration for a commissioned story by *The New York Times*, exactly like Auster did. But if the film plays a number of postmodern games, toying with the boundary between reality and fiction, art and artifice, love is nevertheless palpable in a story which brings out the beauty in an urban setting that combines the spirit of Bedford Falls and the ghost of Pottersville.

An intertextual narrative dance seems to exist between *Smoke* and *Wonderful Life*, most obviously with the role stolen money plays in the films. In the earlier work money is taken by Potter from Uncle Billy when the latter—about to deposit it in the former's bank—misplaces it, setting off the dramatic consequences that lead to the film's climax, while in *Smoke* Thomas aka Rashid spontaneously takes money that a bank robber has dropped close to him and finally he gives it to Augie, when through his negligence he has symbolically robbed his employer of his life savings. Augie subsequently gives this money that is and is not his to Ruby, a former lover who may or may not be the mother of his child to save that teenage child from the worst possible fate, as the gangster that child is currently living with has her addicted to drugs and forced her to have an abortion, which in one of the film's most dramatic moments the viewer sees has traumatized her. One can add that *Wonderful Life* brings in a powerful alternative history

to morally educate its protagonist while *Smoke* concludes with a poignant story within a story, set apart in black and white, for the viewer to contemplate. In Bedford Falls we see a community with a good deal of spirit. Critics claim Mary Hatch is a stereotypical female character primarily interested in marriage. But it must be pointed out she has a choice. Mary goes to college in New York, gets a degree, which George does not despite his strong wish to do so, and she decides not to stay where she studied—this is also the case in the Pottersville sequence, where she is obviously educated and has returned to her hometown even though there is no George. Moreover, Mary clinches the help of the townspeople when she realizes how desperate her husband is, but starts with a prayer, and so we have *ora et labora*—the Benedictine motto of "pray and work" in action! Worth mentioning is that even though George keeps worrying about his earnings, he manages to maintain his household on a single income. Since the 1940s that feat has become increasingly difficult: it has been suggested the fact of women having entered the workforce *en masse* has permitted corporations and employers to pay proportionately less money to their employees, which most often means it isn't feasible for mothers to stay at home with children even if they so desire. And children suffer: a village cannot replace her, as Hilary Clinton proposed; even a house dad is usually not as well prepared as the child's mother.[21] Speaking of villages, it is rarely remembered that in the period after World War II neighborhoods were still quite strong in America, proved by Robert Putnam in his research comparing the 1950s with later periods, noting the dropping levels of "social capital" the closer we get to the present.[22] Using the author of *Bowling Alone*'s terms to make the point about the passage of time, someone born in the United States at the time *Wonderful Life* was released—that is a Boomer—would grow up in a neighborhood with rich ties while he or she would later bowl alone under the aura of so called "expressive individualism" in its various iterations.

The ghost of Pottersville subtly haunts the Brooklyn of *Smoke*, as much through reflecting life in America as the art of the filmmaker, and so film noir aesthetics are unnecessary. The decades that have passed since *Wonderful Life* was filmed witnessed a substantial rise in divorces loosening the foundation of marriages and the general breakdown of people's ability to maintain long-term relationships, the rise of singletons, etc. There are few permanent relationships among the main characters of *Smoke*. The writer Paul may have lost his wife through no fault of his own, but Augie, it seems, has not particularly changed since his affair with Ruby. We see him with a Latin American woman with whom it is doubtful he will stay. Nevertheless, after seeing Ruby's child he conscientiously takes responsibility for the potential result of his earlier casual romance, even if it is unclear if the child brought up by the single mother was his or not.

Further afield, there is a Christmas tradition in Poland that an empty plate should be set on the table during the Christmas Eve feast in case a stranger in need of a meal drops in. The tradition is justified by the historical fact that in the nineteenth century Poles under the Russian partition were sent to Siberia as a punishment for participating in attempts to regain Polish sovereignty. Some of them returned to Polish lands after serving their sentences and had not reached their own homes by Christmas Eve, and so were welcomed to whatever Polish homes at hand would accept them at that special time before they went further on their way. In "Augie Wren's Christmas Story"—in fiction and film—Augie is the unexpected guest at an African American matriarch's empty apartment and actually ends up providing his lonely host a Christmas meal.

Overt religion also has its moment in *Smoke* as it does in the earlier classic. Even more poignantly than in the case of George who initially gets punched in the face shortly after he prays in a bar, Cyrus Cole, an African American father, evokes Jonathan Edwards' angry God when he tells the story of how he lost his arm and wife in a car accident when he drove after drinking to a teenager whom he does not realize is his son.[23] The major narrative mediator of the transcendent in *Wonderful Life* is quite overt in the character of Clarence, the angel who is more a figure from folk religion than biblical, but no less effective for that in George's transformation: proof that popular culture can evoke a deeper sense of the world. In *Smoke* the literal mediation is also visual, not to mention surprisingly more traditional, but completely mute—rather a witness to the spiritual struggles of the protagonists. When Ruby initially arrives from Pennsylvania and faces Augie informing him of the existence of her daughter that she claims was also his, there is a crucifix—not a cross, but a crucifix, clearly a Catholic symbol—on the wall between them in the frame: quite significant in light of the inner struggles both she and Augie will undergo. Struggles that form the heart of the film in a spiritual sense. Moreover, in the coda at the conclusion of the film where Augie's Christmas story that he related orally earlier is poignantly visualized in black and white to the tune of Tom Waits' plaintive song, on the wall above the sleeping blind African American grandmother Augie has visited there is a framed copy of an icon with a Black Madonna and the Christ child watching over the scene. There was no religious reference in the aural story Augie related to the writer, but in the wordless coda that icon in the last shot of the film that augments the earlier presence of the crucifix visually confirms its religious Christmas message.

There are numerous Black Madonnas in the world, many of them paintings or icons, some of them sculptures. Scholars claim the "western ones" likely originated in Asia Minor, inspired by the words of the Bride from the Song of Songs,

"Black am I and beautiful."[24] There were also African paintings of Mary, most notably in Ethiopia, where Mary was black for obvious reasons, but these are primarily known to experts.[25] The Black Madonna in *Smoke* is likely a European one, since it is covered by what appears to be a golden robe decorated with jewels and a crown, with which the Catholic church would traditionally adorn paintings of Mary in sanctuaries where there were documented miracles through the intercession of the Holy Virgin.

Perhaps the best known Black Madonna at the time *Smoke* was released was the icon at Częstochowa, Poland, that gained some renown through its use by the Solidarity trade union during its struggles with the Communist regime a decade earlier. The one in the movie even resembles the crowned version of the icon.[26] Tradition has it that St Luke the icon painter painted it, but its black color stems from centuries of smoke from candles burning beneath the painting, often during masses, and the color was accepted, even vaunted, as in a hymn from 1971, which was sung during pilgrimages to the sanctuary in Częstochowa.

There are a number of different Black Madonnas in Poland, not to mention copies of the one from Częstochowa in numerous churches and homes. Alongside this particular version of Mary there are also the "Beautiful Madonnas," usually sculptures, which evolved from the International Gothic style—although in English they are known simply as Madonnas. Beautiful Madonnas can be said to have also entered Polish folk religion through one of the most touching Christmas carols, "When the Beautiful Madonna Rocked Her Son"—one of the carols sung in a lullaby tune. The carol whose author is unknown has been sung since the at least the eighteenth century, at which time it was first documented. It was quite possibly sung at Christmas plays at that time, a tradition that goes back to the fourteenth century in the country more or less at the time nativity scenes emerged.

Another musical vein among the Christmas carols are the so called pastoral carols—hardly surprising in a country where agriculture plays such an important role. Here we have a special merging of Christmas and folk tradition, and perhaps something else, especially in the highlands of Poland with its rich musical culture. For instance, it is common knowledge that music differs across cultures, particularly at the level of folk and popular music. But there are also striking similarities that are hard to explain by means of possible cross-cultural transfers. Ted Gioia discerns that in some cases indigenous factors produce a common musical style where profusion—that is, outside influence—is hardly in evidence. He gives the example of the similarities of pastoral music in widely divergent cultures and argues this likely results from "the preferences of the herded animals," who are calmed and seem to enjoy soothing music: "a preference that is

reflected even today in our use of the term pastoral to refer both to herding occupations and a specific style of music." Overall, Gioia finds the growing evidence current research has produced of a degree of musical universality in musical production whatever its source quite exciting: "Rather than representing outside influences, they may serve as invaluable reminders of music's power to break down boundaries and geographical divides."[27] The pastoral carols in Poland fit into this large current.

Approximately five hundred Christmas carols have been developed in the Polish tradition and they touch upon all the musical traditions: from folk music to high culture from different periods. If at times folk tradition borrows from high culture in carols the latter repays the compliment. For instance Stanisław Sojka, one of Poland's best contemporary jazz vocalists, loves the country's carols, claiming they are better than English ones, which he also admires. And he is not alone in returning his debt to the tradition, having recorded two albums of Polish carols. It is certainly a tradition in which beauty is love.

Yet if the cult of Mary is at the heart of popular religion in Poland it is another aspect of the folk tradition that has filtered down—or even been appropriated—from high tradition. When Poland accepted Christianity the cult was developed in both eastern Orthodoxy and Roman Catholicism. In the latter, during the high Middle Ages, the cult of Mary as Mater Dolorossa developed, not without influence from Byzantium, as witnessed by the poem *Stabat Mater* that has versions in many different countries. An early Polish text inspired by *Stabat Mater* is the Holy Cross lament from the fifteenth century, with the moving line, "Oh my son, beloved and chosen, / Share your wounds with your mother" which was incorporated by Henryk Górecki into his *Symphony of Sorrowful Songs* in 1976.[28] Indeed, the work, acclaimed as Górecki's "most powerful essay combining the themes of motherhood and death, images of human and heavenly suffering,"[29] demonstrates the inspirational force this presentation of Mary carries in the high art of Poland virtually to this day.

Górecki and his great work is one example that there are still gems in contemporary high music. His *Symphony of Sorrowful Songs* was also recognized and used in one of the great religious works in fairly recent cinema, Terrence Malick's *Tree of Life* of 2011. In one of the scenes of Mrs. O'Brien, the mother with her children, R.L. asks her: "Tell us a story from before we can remember." She recounts the story of an airplane ride she took as a gift after her high school graduation. Up in the air, she is close to the sky where she had indicated to her children is where God lives, and the viewers hear an air from the second movement of Górecki's symphony. Earlier during that movement, the words that had been scrawled on the cell wall of a young Polish prisoner of the SS during

the Second World War are sung. Their author tries to comfort her mother, and includes a supplication to the "Queen of Heaven." As an "ordinary mother" and with her excruciating loss that is a major theme in the film, Mrs. O'Brien fits into that Marian theme. In Catholic tradition, the "tree of life" is also one of the symbols of the cross.

Stanisław Sojka and Henryk Górecki are relatively clear examples of what Andrew Greeley calls the Catholic liturgical imagination that extends beyond the church in its liturgy to affect the imagination and thus the art of Catholics in general. The Catholic imagination stems from the rich sacramental life of Catholics and indicates an immanent as opposed to dialectical perspective—more dominant among Protestants, according to Greeley—of the divine presence in our lives. A rich liturgy augments this sense of the immanent nature of transcendence.

Over the centuries Polish Catholicism has developed a number of personal versions or additions to the central liturgy of the mass. For instance, besides the Holy Cross lament, in the eighteenth century a bitter lamentations service was established during Lent that is popular to this day. In fact, during the second wave of the pandemic in 2020, parts of the lamentations were sung during the masses at advent, that is before Christmas, as well as later on, because of their appropriate emotional and spiritual weight for the situation.

How does this translate into the art of those who are raised within the tradition? It is somewhat easier to begin by comparing it in admittedly broad strokes with a contrasting tradition, such Catholicism with Protestantism. Richard Blake has applied this broad schema to the work of a number of filmmakers who were brought up in the Catholic tradition, claiming that even for lapsed Catholics their worldview and thus art is affected in part by such a manner of perceiving the world. For instance Frank Capra, an Italian immigrant to the United States and brought up a Catholic but having largely abandoned the religious tradition of the family during his creative life as a filmmaker—albeit returning to it later—has distinct themes that fit the Catholic imagination. In *It's a Wonderful Life* discussed above a number of such characteristics are present. George Bailey runs his business in a manner supportive of the community, for which he is considered foolish by his main competitor. And the community saves him during his crisis. This demonstrates the importance of community for the filmmaker, and Blake points out that in the film when a member of the community helps it and vice versa both are strengthened: the individual and the community.

When the salvific moment occurs George and the community that saves his business from a takeover break out into song. Besides a Christmas carol befitting the season, they sing "Auld Lang Syne," a song associated with the New Year and

which stresses "old acquaintances" that save George. Blake points out that in *Wonderful Life* and a number of his other films Capra demonstrates an appreciation "of the unifying force of music" that he gained from his childhood experience in a church choir.[30]

Greeley observes that all four religions of the Book—Judaism, Protestantism, Catholicism, and Islam, he omits Orthodox Christianity, which should be included—possess a high, cognitive tradition which is taught, together with a popular tradition. He notes that Catholicism has the most richly developed popular tradition of the four since, on account of its highly sacramental nature, "it is the least afraid of the imaginative dimension of religion."[31] One can add that through the acculturation of local traditions within the various liturgies the national communities develop a number of rituals with both a religious and civic nature that are adapted to the communities' needs. Rituals, according to Han, are symbolic acts that "represent, and pass on, the values and orders on which a community is based."[32] In a word, rituals build community.

A particularly poignant ritualistic tradition in Poland is honoring the dead on All Saints Day on November 1. Much like the Mexican Dia de Muertos the intensity of the celebration is no doubt augmented by its pre-Christian roots, but it has been acculturated to the Christian tradition. Crucially, it is a ritual that helps the members of the national community confront and perhaps to better accept death—something that contemporary consumerist society tends to pass over, almost to the point of denial. And an awareness of death is embedded in biblical tradition. Moreover, as one Harvard pastor put it, "awareness of death is the first key to the discipline that contributes to the good life."[33] More in line with Han's reflections, the ritual also extends the community to those who shared in creating it before passing it on, and so it strengthens the sense of continuity.

In Lublin where I live as in much of the rest of the country the cemeteries are visited on a truly massive scale at that time by both religious and non-religious Poles. The main and most historical cemetery in the city is particularly flocked by current residents of Lublin and those from further afield whose family members are buried there. Young and old, they come primarily to their nearest and dearest departed. Once all the candles are lit the cemetery is illuminated and at night it visibly glows from some distance.

While they walk through the cemetery once they have tended their own family graves and perhaps said a prayer or two, the visitors take note of many of the other graves. They will note and honor the graves of non-family members, perhaps a friend tragically departed. Many people who have contributed to city's history throughout the generations are buried in this cemetery, coming from all the dominant religious groups. However, apart from those with whom the

visitors have personal ties, it would seem the greatest attention is paid by them on that holiday to the graves and monuments of those who gave their lives for their country in WWII. At one end of the cemetery there is a monument over a mass grave to those killed by the Germans at the castle prison during the course of the war, at the other end a monument to Polish officers killed by the Soviet NKVD at Katyń, a number of whom came from Lublin: both sites have a large number of candles spontaneously lit by visitors at their base.

The fact that uncomfortable historical facts like the Katyń massacre were distorted or suppressed by the Communists. The official version imposed upon Poles was that Germans executed the twenty thousand plus officers. Although the Germans certainly committed numerous atrocities in the country during the war that crime was carried out by the Soviets. The site of the Katyń monument at the cemetery in Lublin was unofficial in the 1980s when it arose spontaneously in a more secluded corner. Visitors to the cemetery on the holiday simply placed candles at that spot and everyone knew why. In a symbolic manner this activity was a gesture of what Timothy Snyder calls "mass personal memory," which acts as a counterbalance to official, ideologically tinged versions of history.[34] Only after 1989 did the site become official. Moreover, although there is a formal Katyń monument in the city erected in 1999, it is unlikely to be visited spontaneously by nearly the number that the one in the cemetery garners during that particular holiday.

In Poland with its troubled past not too far behind it, martyrs of various shades still play the role of heroes. Popular culture plays a key role in spontaneous commemoration. But the larger question is if ritual helps us find a place for death in our lives does beauty help us find meaning in senseless death? Polish art has had to deal with that question in dealing with the country's complex history. This also brings us back to the question of beauty and love.

Wajda's *Katyń* of 2007 opens up the whole complex topic of the Soviet occupation during the war which on account of Communist censorship could only be treated in Polish film after 1989. However, without diminishing the blunt truth of the Katyń massacre, the ending of the film is surprisingly open and invites dialogue. While the officers are being summarily executed, the last two we witness, including an officer with a rosary, independently recite two consecutive lines from the Lord's Prayer before they are shot. The final diegetic lines of the film are:

*and forgive us our trespasses,*
*as we forgive those who trespass against us…*

Wajda's father died in one of the sites of the Katyń massacre, so the prayer in his film can be counted as his own act of forgiveness for the perpetrators. Such

prayers were also recorded during the war. Significantly, early in *Katyń* during a vignette taking place in the Russian occupation zone, one of the wives of the Polish officers is seized and deported into the depths of the Soviet Union with her children, a common fate for many Polish citizens. In one of the memoirs from a Polish woman that had been similarly deported to Siberia we find this moving poetic meditation on the lines of the uttered prayer:

> *Forgive the murderers / of our husbands and brothers, the perpetrators of their demise! / Let it be according to your words, Christ… / And lead us not into temptation… / Lord, when the hour of our liberation strikes, / keep us, keep us from the temptation to seek revenge, which lurks within us…*[35]

The most difficult act of love is to love one's enemies, of which forgiveness of the harms they have inflicted is a major part. Wajda's heart rending film makes a serious attempt to do so. Unfortunately, several years after the film the Russians annexed Crimea from the Ukrainians, and many of their soldiers or their proxies remain in their neighbor's country, where at least some of the massacres associated with the events in the film took place. At the current juncture at least, beauty did not change the way of the world.

But rituals are not only about death. The primary ritual for Polish Catholics—the mass—is about life: here on earth and beyond. The mass probably most closely related to life for most people is the marriage ceremony. When my own marriage took place in a historical church in Lublin, one of the guests was a French friend from Switzerland who had attended a course on the Polish language and culture at the Catholic University of Lublin as I had in the mid-1980s. As far as I knew she was an agnostic and was still involved in a relationship where she lived with a young man at her canton—in other words, the rather standard, rarely permanent male-female relationship in such a country as hers at the time. Yet she was quite impressed with the mass and professed we Catholics really have something. Of course, what she was mostly impressed with was the ritual and not the sacrament that united my wife and I. But rituals are not to be knocked and their beauty is one of the elements that make them cornerstones of a living community.

It is hardly surprising churches are the setting for the most beautiful rituals. Howard Gardner points out "religions have played a constitutive role… in the provision of various forms of beauty."[36] Some religious traditions foster the virtues of moral beauty and honor, wherein Aquinas believed beauty is essentially found, and are a key to the contemplative life.[37] The contemplative life is found in both Catholic and Orthodox tradition. And Lublin is a site in Poland where

these traditions historically met, not so much in contemplation, but in creating a special atmosphere for religious art.

The most beautiful historical site in Lublin and a major one in the country is the interior of a Gothic chapel with byzantine murals. The murals were commissioned by King Jagiello, a Lithuanian prince who was crowned king of Poland late in the fourteenth century after he had converted to Christianity. By the time of his reign the chapel at the castle was already a modest Gothic masonry building that had replaced an earlier wooden one. The king decided it needed murals. Here it must be pointed out that although Jagiełło was a pagan before becoming king of Poland, his realm had conquered a large swath of Ruthenian land, most notably including Kievian Rus, from the Mongols who were occupying it. This meant that a large number of the subjects of the Grand Duchy of Lithuania were Orthodox Christians: in fact they greatly outnumbered the Lithuanians and many from among the ruling class had married Orthodox Christians or taken on their faith. The chronicles of the period inform that the king had an affinity for Orthodox art, but in Lublin the entire chapel interior is painted in this manner. Moreover, since most of such paintings in the country and further east were originally in wooden churches, few of such works have survived to the present, which makes the murals in Lublin all the more valuable.

Within the impressive edifice, five sophisticated themes are presented throughout the chapel, each bringing forth a specific eschatological theme. Art historians note the Orthodox Christian painters may have diverged in some ways from their own canonic program, but they did not change the formal visual language of the images. The two donor pictures with their separate presentations of Jagiello are symbolic of the different religious cultures within the same Christian faith. In one the king is—in Western tradition—mounted on a white steed with an angel crowning him, while in another version on a different wall in the Orthodox tradition a humble Jagiello is depicted adoring the Virgin and Child in the company of St. Nicholas and an unidentified figure.

In juxtaposing the magnificent, predominantly Orthodox styled murals with the vaulting Gothic interior architecture the entire chapel resonates to this day as a powerful symbol of the meeting of Eastern and Western Christianity, which at the time simply incorporated the serendipitous juncture of both religious cultures present in the kingdom through the whims of its patron, even though the leaders of the faith communities in Rome and Constantinople had mutually excommunicated each other a few centuries earlier.

Before he was elected pope in 1978 and took on the name John Paul II, Karol Wojtyła taught at the Catholic University in Lublin: the only non-state operated university in the Soviet bloc. At that time the chapel murals were being

restored and covered in scaffolding. But the priest and later bishop from Krakow must have gained a good deal from his work in the city not too far from the border with the future Ukraine. It may be too much to say this is why he was later to profess that Europe had two lungs which stemmed from the Latin and Orthodox Christian traditions, nevertheless the historical city supports the claim. John Paul envisioned the two lungs working together, which may be partly the case with contemporary Ukraine and Poland, but cannot be fully so without Russia—now practicing revanchist imperial politics. Moreover, Western Europe must shed some of its contemporary woke ideological values which some say lead it in the direction of a soft authoritarianism, and recover more of its roots, if not—fully—its religion. So John Paul's vision at this point is more prophetic than real, and beauty is one of the means to keep their hope alive in the present.

The east-west duality of the Lublin chapel has been recreated in the city toward the end of the 1980s through a magnificent example of contemporary sacred art by the Orthodox Christian icon painter Jerzy Nowosielski in the nineteenth century neo-gothic Chapel of St. Josaphat. The chapel is part of a religious complex of churches and buildings that serve as the Lublin diocese seminary. What is crucial here is the chapel serves the Ukrainian Catholic seminarians: this eastern rite of the Catholic church originating in the Polish Lithuanian Commonwealth in the sixteenth century had been suppressed in communist Poland by the regime, and it was only after the more liberal approach toward the Church begrudgingly ensued upon the election of a Polish pope that its members were able to more openly celebrate their rite and the seminarians were no longer trained in it in secret. Toward the end of this period Nowosielski agreed to paint the iconostasis for the chapel.

The controversial painter and theologian has been called the "Andrei Rublev of our time" by Leon Tarasiewicz, one of the more renowned modernist painters of Belorussian descent in the country. What has created difficulty in the acceptance of Nowosielski's icons within the walls of some Orthodox churches and at times even Catholic churches has been his quite unorthodox approach toward the sacred art. For many of the Orthodox, icons are supposed to follow a canon. Not so for Nowosielski. The artist has been cited as saying: "through its participation in the unearthly world, every icon is different, varies from the others, comes from an individual icon artist, who has given it glory in its own way… An image does not only convey a text with its universal meanings. It also conveys its underlying intonation… An icon juxtaposes the universality of words with the particularity of an image, always speaking of and for itself."[38] This approach to the Orthodox icon places the painter at the crossroads of east and west. And it was this approach that in all probability lost him the opportunity to paint the

iconostasis for the largest modern Orthodox church constructed in post-war Poland, the Church of the Holy Trinity in Hajnówka, close to Białystok, completed in 1982. Among other things, the church is host to the most important festival of Orthodox choir music in Poland, attracting groups from far beyond the country's borders. Nowosielski's preliminary designs for the iconostasis were praised by the artistic community but offended the church authorities. The paradox is that he was friends with the architect who built the church and even helped him with its design.

For complex historical reasons tensions exist between Orthodox Christians and Ukrainian Catholics in Poland, but the artist was very pleased to be assigned the task of painting in Lublin. He was to later express his feelings for Lublin, relating them among other things to the existence of the Gothic chapel with byzantine murals: "The Lublin Byzantium," he stated, "is so different from the Russian Byzantium. It is here, it is to Lublin where you need to see the work of master Andrey in the castle Chapel. Stop, admire the angels sitting on the vault and study the spirit of the city."[39]

In the Chapel of St. Josaphat, the marvelous two-level iconostasis was painted by the artist with oil on canvas on fiberboard, and has four major icons across the wall: striking modernist versions of the traditional *Christ Pantocrator*, *Mother of God and Child*, *Saint Vladimir, Baptist of Kiev*, and *Saint Josaphat*—the patron of the chapel. On the Deacon's Door is an icon of the *Good Thief*. In an interview Nowosielski has commented on its deep significance for him: "He is the Good Thief dying on the cross to the right of Christ and whom Christ himself brought to paradise. I prefer him to any other character traditionally located in this place. In our existential situation, as we are living the drama of faith, he seems the most important figure to me. I am just like him."[40]

Ukrainian Catholic priest Father Stefan Batruch was a seminarian when Nowosielski painted the iconostasis. He recalls the deep impression it made on him. What was noteworthy for the seminarians was the darkness of the icons, which some had claimed gave them a pessimistic air; the artist replied to that concern that even in the pervasive darkness, the sunlight would prevail. "It was very important for me," confesses Fr Batruch, "because I was sensitive to the experience of evil, dismay, injustice—and he presented me with a different perspective. To me Nowosielski's icons emanate light."[41] The light must have helped Fr Batruch, for among his initiatives already in post-communist Poland in the current millennium has been spearheading a joint Polish Ukrainian program taking place east of Lublin on the river that creates the border of both countries, through an event that features performances, fairs, common ecumenical prayer. At times before the Covid pandemic as many as thirty thousand people have

participated. As he puts it, "Our actions are meant to enhance rapprochement between the two nations, to mobilize communities." A much needed initiative in neighboring countries with complicated histories affecting their relationships. The Church of the Holy Trinity in Hajnówka is one the truly impressive examples of modern sacral architecture in the Poland. But first and foremost the beauty of a church is meant to serve its community. This is the intended purpose of one of the exceptional churches near the southern border of the country, built by the acclaimed award winning architect Stanisław Niemczyk. In the Church of Jesus Christ the Savior in the town of Czechowice-Dziedzice he faced a special challenge: his "clients" were the parishioners of the town he grew up in, among them his friends. This naturally imposed upon him the necessity of paying close attention the aspect of community related to the building and its surroundings.

It's been said tradition that does not change dies. Niemczyk knows his architectural tradition but it is a point of departure for a synthesis of the traditional and modern. The parish church has a wall around its grounds, an old tradition that separates the profane space outside but does not as yet designate the sacred space within the church. The architect feels that symbolic elements are crucial in sacred architecture, but they should rather be more open ended so that parishioners do not end up taking them for granted. For instance in the brick work constructing the walls of the church crosses and a tree of life emerge in a more natural manner. Niemczyk himself humbly stresses the significance of his work: "When you plan a church the whole is not a collection of material forms created by a person, but the values, which those forms are to express."[42]

The manner in which the church was built helped integrate the parish community. For one thing, the parishioners themselves raised most of the building, a number of them arriving each day during its construction and starting work after the morning mass. The architect himself was frequently on the construction site helping to coordinate the work and making amendments to the plans when necessary. The church was completed at the onset of the new millennium—the three towers of the edifice symbolizing the different millenniums of Christianity. In the end, Niemczyk was rewarded by the parishioners themselves when they told him: "When we were building and now when we are praying, both of them we learned to do in common and it gives us great joy."

If the Church of Jesus Christ the Savior can be considered something of an exceptional exemplar of a parish church designed by an acclaimed architect, I would like to turn now to an example of a more ordinary parish church in Lublin with a closer look at a particular example of its liturgical art work, the Stations of the Cross that adorn its walls. The Stations of the Cross are what can essentially be called functional art that goes back to the Middle Ages and achieved

their contemporary form in the seventeenth century. Basically, there are fourteen images of Jesus on his way to his crucifixion and finally his burial. So if this liturgical art work can be called functional, it is not just any function, but a religious and spiritual one at the heart of the faith. During Lent a special Friday service makes use of these images.

Julian Spalding points out that for the longest time art was created in the service of philosophy, religion, politics and science for far longer than it was for its own sake. This is easier to understand when we see works in their original context. For instance, we can still see Caravaggio's masterpiece *The Calling of Saint Matthew* in the Contarelli Chapel in the church of San Luigi dei Francesi in Rome. In that church the religious essence of the painting takes on a radically different meaning then it would as a painting in the best possible gallery, even the Vatican gallery where another of his masterpieces is found. There is not much special lighting on the canvas as we would find in a gallery; primarily the light from the church windows, like the one above the painting, which filters in the interior of the niche of the edifice creating shadows not all that dissimilar from what we see of the image on the painting.

From the Caravaggio painting emanates an extraordinary beauty; to no small extent that is also true of the Nowosielski iconostasis in the city. In this particular parish church in Lublin there is what might be called an "ordinary" extraordinary beauty. If I have focused my attention on the beauty of the city through the chapels that place it at the crossroads of Europe's two lungs, to use John Paul II's metaphor, I also find a significant part of that quality in this particular parish church, at least in my own perception—especially in one particular image from the Stations of the Cross in conjunction with an adjacent sculpture.

The parish may not be all that special but it does have its own history. In 1987 John Paul II stopped at Lublin during his last pilgrimage to Poland before Communism was overthrown. At the largest gathering and mass in the city at the site where a new parish was about to be constructed he suggested another parish should be dedicated to the first Polish saint he canonized. And so very soon afterwards St Urszula Leduchowska parish was planned and established while its church was constructed and opened in what was already post-Communist Poland: an exemplar of the postmodernist religious architecture of the time. Like a number of other churches it breaks with the post-Second Vatican Council suggestion that the inner church space be largely open, with one side chapel dedicated to the devotion of Mary.

The Stations of the Cross in the church are a mixture of modernist art and a modernized traditional style. The traditional style is virtually taken from Hollywood movies, quite possibly inspired by some of the biblical classics that were

shown in parish halls in the communist period, with its realistic versions of the *via dolorosa* where the copper bass relief depictions of the protagonists—in each case Jesus, additionally Pilate, Mary or others on particular images—are framed in medium shot-style, that is from the waist up. The modernist framework is found in the irregular form that frames each of the images.

Where does the Latin Catholic/Orthodox confrontation and dialogue come in? Through the image of Jesus in the tomb after he is taken down from the cross. This final image of the fourteen Stations of the Cross in this church is obviously modeled on Hans Holbein's version of Christ in the tomb, which shows the body of the dead savior decomposing. This was a daring Renaissance innovation, since up until the Middle Ages Jesus' body would never be shown decomposing. Greeley points out that the humanist turn in Catholicism at the time wished to stress the humanity of Jesus that in some religious traditions or heresies' was underplayed, and one sign of this humanity is that his death was genuine.[43] Conversely, one of the signs of saintliness had been that upon their deaths the entombed bodies of saints would not decompose. This tradition is captured in contemporary art in J.R.R. Tolkien's *The Lord of Rings*, where in the Appendices Aragorn dies and the saintly king's body does not decompose. Peter Jackson incorporates this story visually when in the *Two Towers* installment of the trilogy the elf-lord Elrond attempts to discourage Arwen's love of the mortal prince by reminding her that he will die. It might be added some of the most beautiful singing in the trilogy was in the scene where Aragorn's serene corpse is shown in the glass encased tomb.

I am uncertain if the tradition is still so strong in Orthodox Christianity, but as late as the second half of the nineteenth century when Dostoevsky visited Western Europe he was shocked by Holbein's painting for the very reason of the decomposing Christ. At least one biographer suggests this traumatic experience influenced him in *The Brothers Karamazov*, where Father Zosima, the youngest brother Alyosha's master at the monastery in which he is a novice, dies and the fact that his body decomposes puts into question his sanctity during life.

But the artist who created the Stations of the Cross at the parish church also did the sculpture over the main altar. Having referred in that final image to perhaps the strongest version of Jesus' death in western Christian iconography apart from scenes of the crucifixion, he chose the most powerful image of the resurrected Christ above the alter: Christ Pantocrator—that is as the lord of creation. In this case the artist maintained the more realistic presentation of the figure similar to the images in the Stations of the Cross rather than a highly stylized version. More importantly, this is an image of Jesus that is common to both Orthodox and Catholic Christians. The sculpture in the church even has a rare

version of that image with both arms of the Christ extended in mastery—more in line with the resurrection which it also represents.

I like to think of the combined dramatic image from the Stations of the Cross with the ecumenical Pantocrator in that simple church as a prophesy of the two lungs of east and west Europe finally breathing together. In 2012 the patriarch of Moscow came to Poland and signed a document with the Catholic Church in the country, which was a milestone in religious relations between the two branches of the faith. But since then with the hybrid war between Russia and Ukraine, together with the unstable geopolitical situation it spawned, even the Orthodox have troubles among themselves, with the patriarch in Constantinople acknowledging the autonomous church in Ukraine while Putin has not, giving some indication of how politics and religion are mixed. Thus at different levels the two lungs have to wait to work together harmoniously, even at the religious level.

Finally, if among other things I have discussed above how love in ritual and art aids in accepting death and how in religious art it expresses the belief it can be conquered, can love have any influence at the more mundane level of politics and introduce beauty in the body politic?

One of the events that created the Polish Lithuanian Commonwealth was the formal union which was substantially negotiated and finally signed in Lublin in 1569. It was this union that John Paul II referred to when he came up with the slogan "From the Union of Lublin to the European Union" in order to encourage Poles to vote for accession to the EU in the referendum held for that purpose in 2004. The Union of Lublin was the culmination of a series of negotiations between the Polish and Lithuanian sides formalizing the personal union that had united them since they had the same monarch in 1385. One of the preliminary acts, signed at Horodło in 1413, starts with this unusually inspiring invocation:

> Whoever is unsupported by the mystery of Love shall not receive the Grace of salvation… For by Love, Laws are made, kingdoms governed, cities ordered, and the state of the Commonweal is brought to its proper goal. Whoever shall cast Love aside, shall lose everything.[44]

It is hard not to be touched by such high mindedness. Obviously, once it emerged a century and a half later, the new state did not exactly live up to its early intent to be governed by love. Moreover, unfortunately the pact was solely between Poles and Lithuanians, leaving out the large Ruthenian population of the polity. Yet although its failings were substantial, much that was valuable flourished for a time—in the long term even partly informing the character of the Polish national community that came into being centuries later.

Nevertheless, however substantive the failings of earlier republics or commonwealths such as the Polish-Lithuanian one, which came to an end in the eighteenth century, the horrors of the century we have just left behind certainly dwarf them. And if we take T.S. Eliot's warning that the world may end with a whimper rather than a bang as a metaphor for what is happening currently then we can find whimpering atrocities that are quite terrible in their own right. All of the above seem to confirm Solzhenitsyn's initial objections to the notion of beauty saving the world. Where does that put the place of love and virtue: is it really absent?

Love is among the intangibles of history, at least at the socio-political level. Thus it is certainly easier to trace its absence or all the more so love's contradiction than its presence. This does not prove that love is not a driving force of events at some level; merely that the tools of the journalist or historian and other scholarly disciplines are still lacking in sensitivity to detect it. No doubt in politics if at all it is present or at least easier to detect at the grass roots level community where it helps create the common good we will look at more closely in the next chapter.

It is a fascinating question whether historians and their like will ever come up with investigative tools sensitive enough to plumb the force of love in historical events and even cultural accomplishments, except at more obvious junctures in art such as those I have attempted to illuminate. But it is the force that makes history—and art and culture in all its incorporations—truly human!

So, yes, all we need is love… and the practical wisdom to allow it to guide us and inform our creative labors as well as the moral rectitude for it to also guide our acts.

# Chapter 2 The National Community and the Common Good

Aside from the personalist philosophy that informs my examination of the common good, I will also follow something along the lines of a constrained view, which will be explained below. This essentially looks realistically at the limitations of human nature, and is one of the keys to my exploration of the good as a transcendental in what might be called its practical form, without which it is effectively an abstract ideal. I myself have chosen to limit the range of this exploration of this transcendental primarily to the problem of the common good as it is developed within the smallest unit, the community, with the family at its base, and arguably the largest workable unit to date: the national community. An even further constraint through which I will try to see the world of the family and beyond—as should be obvious from the above—is to primarily concentrate on the national community of Poland where I have lived almost four decades now and raised my own family.

Among the difficulties of creating the common good in contemporary, largely consumerist societies, is the self-centered individualism they tend to foster. Individualism does not necessarily go along with being self-centered, but the pairing is nevertheless common enough to not rarely affect substantial segments of societies. At one of its seeming societal high points in the final decades of the last century the phenomenon was labeled a "culture of narcissism." The prominent communitarian philosopher Charles Taylor challenged that charge by forwarding an interpretation that members of these developed societies are primarily bound by an ethics of authenticity wherein they aspire to be true to themselves and their originality. "This is the background that gives moral force to the culture of authenticity," he argued, "including its most degraded, absurd, or trivialized forms."[1] He also proffered some ideas as to how the ethos can avoid being trivialized and better serve society. In *The Disappearance of Rituals* of 2020 Byung-Chuk Han cites but is not convinced by these arguments. Rejecting Taylor's claims he curtly retorts: "The narcissism of authenticity undermines community."[2] Han objects to the alleged moral façade of contemporary authenticity, claiming it leads to a form of self-exploitation, which the neoliberal regime appropriates into its production process. The seeming originality of individuals is actually a form of conformism, evident, among other places, in the fashion for tattoos, wherein the body becomes an "advertising space." As mentioned in the previous chapter, for Han rituals are symbolic acts that "represent, and pass on,

the values and orders on which a community is based." Rituals are thus crucial for building community, while much in the neoliberal order, he claims, leads to the erosion of community. It is hard to say whether the neoliberal order is the only culprit, but certainly a number of the flaws Hans lists are present.

Polish society is quite interesting for consideration because it is at a cross-road. If we were to map it onto Han's schema the seemingly most obvious course would be to present an until recently traditional society rich in community-building rituals that has been bludgeoned by the neoliberal order together with its accompanying economic processes which have largely transformed it. Among other things Poland has moved significantly in the direction of a contemporary secular, atomized society. But it must nevertheless be stressed that Poland was only apparently a "traditional" society at the end of the Cold War. If the neoliberal order has indeed played a major role in the erosion of nourishing forces of community such as festivals and rituals that allow it to flourish and develop an identity, then it can be said very similar and in some ways more powerful forces were confronted during its subjugation to the communist system within a totalitarian state. During the Cold War, community was attacked by communist collectivism, which also attacked religion, the major source of ritual. Why Poland exited that regime in a relatively healthy condition is a long story albeit some straightforward aspects are fairly well known.[3] Through great effort the national community largely overcame the socially destructive forces of the communist system aimed at atomizing Polish society, and thus significant traditional elements of the society were saved, especially if we compare it with neighboring countries. And so these "traditional" elements had confronted and largely overcome a very modern, and ruthless opponent. Now the situation is quite different, and community confronts a number of the seductive—rather than coercive—forces described by Han. And community is a crucial force for working out the common good although it is not quite successful in confronting those corrosive forces.

Another seminal element in Han's list of pathologies of the neoliberal society is the lack of closure, or at least a certain manner of closure. He somewhat traditionally lists nationalism as a negative, fundamentalist form of closure, while culture is a positive form that aids in providing an identity for a community. Quite important in his reflections, culture is receptive to what is foreign, thus it helps create an "*including identity*." Despite its undoubted specificity, a national culture is not a closed vessel. And so Polish culture is obviously inclusive in Han's sense—basically drawing upon a broadly understood European cultural wealth, with some of its specificities more evident; historically, for instance, early on we see the Italian renaissance, evident in many buildings in older cities, while the

more contemporary Italian neorealism influenced the Polish School of Film—most prominently in early films of Andrzej Wajda—just to give a couple of examples along the same cultural trajectory of creative incorporation.

Globalization, on the other hand, creates a hyper-culture that perforates healthy boundaries and the natural attachment of people to sites. "A de-sited hyper-culture is additive" and thus hampers closure; what is more, it propagates "a cancerous proliferation of the same, even to the hell of the same," argues Han. This is one of the causes of the culture wars—although he does not use this term—since, as he puts it, "The strengthening of site fundamentalism … is a reaction to hyper-cultural non-sitedness."[4] What he is referring to is the confrontation of radical nationalism with rootless cosmopolitanism. Needless to say the confrontation is hostile, and both sides are at fault to different degrees.

Certainly the Polish national community, at least at present, has a fairly strong sense of "sitedness." The forces of globalization have rather a transnational face in the form of the European Union. But Gerard Delanty has pointed out it is not so easy to define Europe as a political community since, despite efforts to the contrary, "it has become increasingly apparent Europe is not reducible to the EU any more than it can be explained as the sum of its national units. In short, Europe is a reality, but what kind of reality is it?" [5]

For a scholar, such a problem can be open-ended. For a Eurocrat, the solution is not always in line with the needs of a national community. In his book *The European Dispute Concerning Human Nature* of 2017,[6] Michal Gierycz, a political scientist, set himself the task of coming up with a political anthropology of his national community in relation to the EU. He wisely hit upon using the key concepts from Thomas Sowell's book of 1987 *A Conflict of Visions*, in which the role of visions underpinning political ideologies is explored. Sowell argues social visions act as a kind of cognitive road map that guide everyone, since no mind can encompass social reality in its full dynamism and complexity. Crucially, when political leaders tap into broader social visions, they are able to create an agenda for both thought and action. Sowell focuses on two such broader contrasting visions that he persuasively argues have inspired politicians and influenced societies for the last centuries, the constrained vision and unconstrained vision of human nature. The constrained vision sees human nature as flawed and with a tragic bent, while the unconstrained vision is a moral vision that focuses on human intentions and ideals, and at times veers toward a dangerous utopian bent.

Upon presenting and critiquing Sowell's anthropological conceptions, Gierycz develops them further for his specific analysis plumbing the understanding of human nature in current European politics at the EU level, that he

argues tend toward an unconstrained anthropology—one can say that this is additionally demonstrated by an increasingly woke agenda. Conversely, he finds the constrained vision particularly useful for probing a national community. In his explication of a constrained anthropology on this basis he concentrates on what he takes as its underlying theological assumptions that interest him. Both in Sowell and in other contemporary political thinkers Gierycz detects an implicit assumption of the doctrine of the original sin through an awareness of the inherently flawed side of human nature. Yet although human nature has its limitations, he argues following Sowell, taking this fact into account allows for organizing social matters in a more realistic and stable manner than would otherwise be possible. From a historical perspective Gierycz points out that even in Greek philosophy a constrained vision of the human being was present in the concept of natural law, which implied certain limits. The social nature of humans was also stressed, starting with the family and working upwards. From a similar timeframe one could also go back to the famous debate between St Augustine and Pelegius as perhaps the earliest confrontation of the constrained and unconstrained view.[7] Later modernity largely went its own way with a greater stress on individualism but certain currents within it maintained a constrained anthropology to some degree, for instance it can be detected among the contemporary communitarians. Some communitarians even praise such broad communal feelings as patriotism. Gierycz probes the theological underpinnings of Sowell's stress on the checks and balances necessary for the state, eloquently captured in James Madison's famous dictum: "If men were angels, no government would be necessary."

The constrained anthropology that Gierycz proposes for the national communities is largely analogous to Han's positive closure that he locates in communities through culture and their siteness. The Polish national community also has a tradition that fosters an "including identity." In an interview John Paul II praised the Polish-Lithuanian Commonwealth in the late sixteenth century: a multinational and ethnic polity with a wealth of religious diversity, initiating a period of relatively harmonious coexistence uncommon in Europe at the time. As the Polish pontiff himself said of that golden era on another occasion, "for five centuries the Polish spirit of the Jagiellonian era prevailed. This made possible the emergence of a Republic embracing many nations, many cultures, and many religions." And he added optimistically: "All Poles bear within themselves a sense of this religious and national diversity."[8] Yet he was realistic enough to note that the tradition is not universally accepted within the current Polish national community. Nevertheless, this element of their identity has not completely disappeared. We will return to this question further on.

What is most evident at this juncture, on account of the trials and tribulations of their history, many Poles—especially those who remember the Cold War—feel a particularly close relationship with their country. How can one describe this sense of belonging? Patriotism is a good starting point. Moral philosopher Alasdair MacIntyre argues that being born into a particular community is essential to our moral being. Virtues do not develop in a social vacuum, and so:

> *If* first of all it is the case that I can only apprehend the rules of morality in the version in which they are incarnated in some specific community; and *if* secondly it is the case that the justification of morality must be in terms of particular goods enjoyed within the life of particular communities; and *if* thirdly it is the case that I am characteristically brought into being and maintained as a moral agent through the particular kinds of moral sustenance afforded by my community, *then* it is clear that deprived of this community, I am unlikely to flourish as a moral agent.[9]

This moral grounding involves a number of forms of civic virtue, among them those that are at the foundation of genuine relationships, such as loyalty. MacIntyre stresses, "So patriotism and those loyalties cognate to it are not just virtues but central virtues."

As a rule Poles prefer to distinguish between a positive patriotism and a negative nationalism. But even this is becoming problematic for parts of the liberal elite. If as Michael Sandel complained that when western liberal and leftist parties stopped referring to patriotism they created a vacuum filled in solely by the right, the problem is also becoming noted in Poland where the old liberal guard are increasingly frightened by the phenomenon. Yet, as one of its members Wiktor Osiatyński has bitterly noted, "Rejecting, or even ignoring patriotism by the liberal elite has ushered the way for the nationalistic right to appropriate these patriotic feelings [of Poles]."[10] And patriotism remains quite strong among Poles, with a poll at the time of writing placing three quarters of them as either strong or moderate patriots.

However, for all its virtues patriotism is rather narrow in scope for describing the fullness of the relationship between a national community and its homeland, especially at a notional level. What is crucial for a national community is some conception of the common good. And so despite its problematic nature, for my purposes few terms exist to replace nationalism in this vein, which might be called the arena where the conception is worked out in particular communities. Whether one calls it patriotism or not, nationalism in its arguably positive version constitutes the emotional and ethical relationship between the members of a national community and their homeland.

Among the more prominent supporters of a "positive" nationalism are the Israeli scholars Yoram Hazony and Yael Tamir. The conservative Hazony argues a nation offers an unsurpassed basis for a state, since it allows for the realization of the human aspiration for self-government and communitarian freedom in the most satisfactory way. He points out that nations confer meaning on individual members, providing means for the development of the particular, that is, true cultural diversity through the distinct culture of each nation. Although nations have their faults, he counters that contrary to what many think "liberal imperialist political ideals have become among the most powerful agents fomenting intolerance and hate in the Western world today."[11]

Tamir extols somewhat different facets of nationalism among which she acknowledges the human need for political leaders and policymakers who prioritize serving their own national communities. Essentially she has a fairly organic sense of the nature of nationalism, also claiming that there is no clear distinction between patriotism and nationalism, which may sound odd—one can imagine a patriotic duty, but hardy a nationalistic one—but is perhaps valid at the conceptual level if not at the vernacular one, at least in her argumentation. Tamir calls for the development of a liberal form of nationalism to counter that of the populists who according to her are essentially filling in a vacuum in liberal politics. In her view, among other matters: "Unlike civic nationalism, liberal nationalism does not ignore the role of identity and membership; hence it is inherently attentive to… the disadvantages with being a minority and seeks ways of ameliorating them."[12] Liberal nationalism thus possesses a measure of non-ethnic inclusiveness. Tamir even feels this project can help overcome some of the failings of liberalism.

Regarding Poland, although it is currently largely ethnically uniform—before the Second World War that was not the case—some elements of Tamir's liberal nationalism are likewise present or worth consideration there. For instance, the Jagiellonian tradition mentioned above are part of its heritage. However, currently more pertinent for the question of a positive nationalism in the country, Hazony discusses the role of religion in nationalism. He is hardly alone, it has been fairly convincingly argued religion continues to play a key role in the lasting appeal of nations to the members of national communities in today's world. What then is the connection between religion and the political community? Rabbi Jonathan Sacks makes a major point when he argues that religion protects the members of the national community from the overbearing tendencies of the state. Sacks pertinently claims religion is "part of the ecology of freedom because it supports families, communities, charities, voluntary associations, active citizenship and concern for the common good… Without it we will depend entirely

on the State, and when that happens we risk what J. L. Talmon called 'totalitarian democracy', which is what revolutionary France eventually became."[13] We see elements of this tendency in the cancel culture as well as the reductionist view of what it means to be human that permeates numerous western societies and is seeping into Polish institutions as well.

Yet the healthy counterbalance religion creates to the state depends on its strength in a given society. Even in Poland, although religion still has a fairly strong impact on communal life, secularization is advancing. Ronald Inglehart links the advancing progress of secularization with growing wealth and the rising standard of living in such societies where this process occurs, and this is pretty much the case in Poland. Furthermore, he makes the claim that by and large this is an emancipatory phenomenon.[14] Authors in Poland like the late Fr Maciej Zięba are familiar with the negative stereotypes concerning religion and present strong arguments against them. However, even the most sensible argumentation does not carry much weight in contemporary polarized societies with a highly biased meritocracy in this and other matters.[15]

Inglehart is a prominent social scientist and his claims must be taken seriously whether one accepts them or not. However, a significant part of the accompanying phenomena he describes are a matter of interpretation. In his essay cited above, Han implicitly challenges the sanguine view that the socio-economic processes accompanying and also driving secularization are particularly emancipatory; on the contrary, he forcefully argues the disappearance of "rituals"—obviously so important in religious traditions—drives the "erosion of community."[16] Looking at Poland the sociologist Jarosław Flis in principle agrees, counterintuitively pointing out research in the country suggesting that, among other matters, believers tend to treat people of opposing viewpoints more gently than non-believers. He further asks if religion which is the mainstay of community is lost in the country, what will replace it: certainly not the ideals of the progressive camp, he argues. "The progressive camp thinks that people are communitarian because they are religious, and once they give up religion, then communitarianism will end. And as a result people will be more individualistic, and this suits the progressive camp since then people will become more like them." He goes on, somewhat ominously:

> But this is not necessarily the case. Above all people are religious because they are communitarian. If they give up on religion, they will not stop being communitarian, they will only find a different medium through which to express community—not necessarily more desirable or aesthetic than the Sunday mass.[17]

Flis mostly looks at religion and ritual from the perspective of how it affects a society, which may miss what is most important within it but is certainly important for the common good. It is also worth recalling that not all that long ago, the end of the twentieth century give or take a decade or so, the idea that we were living in a post-secular age was making some headway among those interested in the place of religion in modern societies. The primary evidence was to be found in places such as the United States with its highly religious population and ditto Poland, as well as in a number of post-communist countries where religion seemed to be undergoing a revival after the official atheist ideology of communism was finally cast aside once the subjugated nations regained their sovereignty. As is evident from the triumphalism of social scientists such as Inglehart concerning advancing secularization, by and large this optimism concerning the modest return of religion has faded, with a few significant exceptions such as Africa where religious practice continues to experience growth.

One of the remaining expressions of the post-secular view among social scientists in Poland is proffered by Mirosława Grabowska in her book of 2018 *God and the Matter of Poland*.[18] Although she does note trends of significant decline in religious practices in Poland, she is nevertheless cautiously optimistic about the overall future of religion in the country. Moreover she is not inclined as even some Catholic thinkers in Poland to regard folk or popular religion in the country as shallow, maintaining it does possess its own genuine depth. The strength of the religiosity in the countryside has also been noted, which creates a resource for religion in the whole country. This is partly confirmed in that some parts of the countryside with strong religious practice have traditionally had the richest social ties and active community organizations.

As an aside to the discussion as to whether secularization is emancipatory or not, where arguments like gender equality might be bandied about, it turns out that in Nordic countries which are both highly secular and gender equality is very high, there is a much higher level of partner violence than in Poland. In the study *Violence Against Women: An EU-wide Survey* published 2014, Scandinavian countries were at the top of the list for women reporting past abuse, ranging from 52% to 46%, while Poland was at the bottom with a couple of other countries at 13%.[19] It has been argued the cause for this is likely connected with the high rate of cohabitation in Nordic countries. And while religion is not mentioned as a reason for the low rate of abuse in Poland, it plays a role in the popularity of marriage, with all the incumbent benefits.

Now a major context for many aspects of Polish social and political life, entry into the European Union with the close ties and proximity to the wealthier European countries that ensued has provided a model for many enterprising Poles,

affecting lifestyle and worldview. At the bottom of the European context—both in its positive and negative consequences—are obviously deep ideological currents and broader worldviews competing with each other. In his book *Social Harmony* (2017) political philosopher W. Julian Korab-Karpowicz emphasizes the importance of religion in the public sphere, stating: "Although not everyone is religious, when considering a flourishing society the final end of humans should always be taken into consideration."[20] This seemingly uncontroversial view goes against the grain of more aggressive secular views that banish religion from the public sphere when possible, relegating it strictly to the private sphere. And thus any presence of religion there, especially in the political realm is categorized as interference. What binds a number of these views is the sense that religion does more harm than good. Advocates of this view exist in Poland as well, most notably found among those advocating a woke worldview, which is gaining strength in the country. But needless to say the political issue is hardly the whole story; neither in Poland nor elsewhere. There are also competing views of what constitutes the good: for instance, how we define human dignity and all the matters that stream into that question.

A further consideration of inquiry concerns religion and nationalism as major axiological building blocks of socio-political community. In *Trust: A History* (2014), Geoffrey Hosking has indicated generating trust as one of the most important social functions of religion. In Western Christianity, beginning with the parish, which augmented solidarity in numerous forms, and especially through supporting that basic unit of trust, the family, the rings of trust expanded outwards to largely end at the evolving nations. Hosking looks at the EU and its modestly successful attempts at providing "a broader radius of trust" for its older and newer members, but points out that when a crisis breaks out, the peoples of the various national communities look to their own nation-states for solutions and protection. And when a genuine crisis broke out this year, Polish political philosopher Dariusz Gawin noted during the period when the fear of the coronavirus epidemic in mid 2020 had already reached a high level that the members of national communities paid attention to the steps taken by their own governments which concerned them directly: "The televisions in Warsaw, Berlin or Rome do not show the commissars of the European Union providing the most up to date information or uttering key decisions… Attention is focused on the governments of the particular states. They are the sources of genuine power and are responsible for the manner in which they use it." More recently, the difficulty of the European Commission in securing sufficient numbers of vaccines for member states augments this point.

The above illustrates Hosking's point that with all their resources more finely attuned to their citizens' needs, the nation-state will probably "outbid all rivals in providing a focus for different kinds of trust for the foreseeable future."[21] Trust is thus an element of creating a larger community conducive to the good life at a basic level, but it can only be spread out so far while remaining a relevant social force. What needs to be stressed at this juncture, in the light of the existence of a crucial good such as trust, speaking of a national community is not an oxymoron. One could perhaps even go a step further following Paddy Scannell, and see in trust a form of love[22]—which he connects with communication, also, we can add, a key to community. And so at this juncture we have a realistic channel to talk about love and the common good in relation to the national community.

Nevertheless, as alluded to above in many analyses nationalism is on the defensive, and not without substantive reason. The historical sins of nationalism are fairly well known; the relationship with fascism comes to the fore. But, among other matters, behind these views is often enough a limited historical awareness that, as Jakub Grygiel puts it, "one of the greatest threats Europe faced in the twentieth century was transnational in nature: communism, which divided the continent for 45 years and led to the deaths of millions."[23] Tragically, one can say, there simply is no form of organizing human affairs that is incapable of taking wrong turns or possibly carrying out atrocities. More specifically, neither the national nor transnational orders are immune to aberrations. Here one must recall Augustine's observation that every good has its shadow: consequently, abandoning the path of a particular good such as nationalism once in a given case it turns sour, even deadly, for a time can lead to new errors—as arguably seems to be the case with the most uncritical advocates and agents of the current European project in their naïve "unconstrained" belief that transnationalism will solve virtually all contemporary social problems—if the new course is not approached with extreme care. Which is not to say that nationalism does not need reexamination or to be approached with caution if it is to work socially and ethically for its community at home and abroad. In political terms both forms have their uses and abuses, but naturally the smaller unit is simply more manageable by fallible humans.

In the case of Poland at any rate, bearing in mind that during the Second World War and under communism the country experienced violent oppression from both a neighboring fascist imperialist regime and a transnational one it is easier to understand the deep and fairly widespread commitment to national sovereignty, in some cases perhaps excessively demonstrated, as well as the gratitude to the religion that aided in obtaining it. And what Poles experienced from totalitarian transnationalism should not be lost on the members of the European

community who were more fortunate in this respect. What is often termed Euro-scepticism in Poles is to a great extent a different vision of Europe that is rooted in its weighty historical experience.

Religion within the national community fosters forces such as trust that work toward the common good. Building trust is a key task for a society of East Central Europe that has exited a collapsing political system which in its Soviet heartland had promoted "maximum distrust," as Hosking has argued. The European Union that Poland has joined, on the other hand, was supposed be the safe harbor anchored in freedom. However, some things are also rotten in Denmark, or rather Brussels. In a manner not dissimilar to Hazony, Polish philosopher Ryszard Legutko, a member of the European Parliament, notes in *The Demon in Democracy* (2016) that those who call themselves liberals are quickly becoming more intolerant of opposing viewpoints and those who refuse to conform are treated with scorn and the machinery of the union is used to bend individuals or groups to their will. And the problem is beginning to also penetrate the Polish national scene in its own manner, that is without the assistance of state machinery for now, but—for instance—from outside pressure through woke policy promoted in international corporations where many young and some not so young Poles are employed, not to mention NGOs of a similar bent. Legutko has a strong view concerning these trends: "the deeper wisdom was to copy and imitate [the EU]. The more we copied and imitated, the more we were glad of ourselves. Institutions, education, customs, law, media, language, almost everything became all of a sudden imperfect originals that were in the line of progress ahead of us."[24]

The problem with institutions shows that it is not just a political problem. Poles are experiencing their own version of a meritocracy that Michael Sandel argues is a key factor in the divisions in advanced societies, and detrimental to fostering the common good. Thus if Poland was liberated from communism to no small degree by a workers' revolution, what the country is witnessing now is the onset of "the reign of technocratic merit" present elsewhere, that, as Sandel puts it, "has reconfigured the terms of social recognition in ways that elevate the prestige of the credentialed, professional classes and depreciate the contributions of most workers, eroding their social standing and esteem."[25] Moreover, the transnational mindset that is developing among the elites in Europe has the side effect of creating a center and periphery. Guess where the countries of Eastern or East Central Europe lay? It is significant that in scholarly studies of European heritage or memory, the region with Poland is not infrequently barely touched upon, and the House of European History that opened in Brussels in 2017, while obviously treating the aberrations of Stalinism, overlooks the overall criminal

nature of the communist system: for instance, the Soviets ruthlessly crushing the Hungarian and Czechoslovakian revolutions of 1956 and 1968 is omitted.[26] Polish society is divided along a number of lines; hardly unusual in any pluralistic society. Although the new divisions have not been adequately named, one political scientist, has coined the self-explanatory terms "localists" and "internationalists" to describe perhaps the most pertinent current divide within European societies.[27] These worldview divides are also visible along political party lines. Poles generally consider themselves European and their attitude toward the EU remains quite positive across the board, with only a small group of genuine Eurosceptics present in the society. To put it in more traditional terms, in Polish society there is a small although growing group of cosmopolitans and right-wing nationalists at opposite ends of the spectrum, while most citizens range somewhere in between. But the divide naturally does play a role as to how this attitude toward Europe is expressed, or patriotism itself for that matter. Poles have their own Europe, or rather several of them, nor—as Delanty notes—is Europe necessarily limited to the European Union. However, for examining the Polish national community closer it is best to start at its most basic unit: the family.

The virtually iconic Solidarity movement of the 1980s has been called a "self-limiting" revolution. This was largely the strategy of its leadership, aware of the genuine threat of intervention by either the Polish communist regime or its Soviet overlord. John Paul II's insistence on nonviolent resistance also played a crucial role. But there is a key scene in Andrzej Wajda's *Walesa: Man of Hope* (2013) that illustrates one of the less noted yet essential social forces maintaining this strategy. After the August strike of the Gdansk shipyard workers in 1980 has been renewed despite the seeming initial success of negotiations, kids gloves are off and the regime's forces are gathering for what seems to be an inevitable violent confrontation with the workers occupying the shipyard. Two workers are near the gate and discussing the turn of events. The first worker is young and unmarried. He is ready for a fight because he can no longer tolerate living under the "Russian" heel. The other is slightly older and married. He wishes that they had quit while they were ahead. Within his film Wajda seems to stress how both workers' arguments have their validity.

The struggle of both perspectives is personified intensely in Walesa himself who fights for freedom and dignity but is always aware of the consequences for his family. Indeed, virtually all his actions are shown to have consequences for his wife and family. Nevertheless, in *Walesa*, Wajda shows clearly enough that at a certain level family was a key to successful resistance. It inspired political realism not to be too rash, but also additional motivation to persevere in the fight for change.

In communist countries dominated by the Soviet Union, family breakdown was generally quite widespread. This phenomenon was likely among the major sources of the demoralization of communist societies. A witness to "family" life in the Soviet Union during the twilight of its existence in the early 1990s was the British correspondent Peter Hitchens, who observed that "in mile after mile of mass-produced housing you would be hard put to find a single family untouched by divorce"[28] While only a journalistic impression it nonetheless gives some notion of the demoralizing reality connected to the family that to a greater or lesser degree affected much of the Soviet Bloc. And it seems hardly accidental. Next to religion, the family as an institution was in quite low esteem by Communists since it made the individual family members more difficult to manipulate. In Poland the two were indeed closely interrelated; Cardinal Wyszynski who led the Polish Catholic Church from the Stalinist period to Solidarity had made it a primary concern to strengthen the family. In a manner of speaking it can be claimed Solidarity truly began in the home.

It was with this significantly enhanced through religion reservoir of "human capital," to use economist Gary Becker's term for the contribution of the family to society and its economy, that after 1989 Poles started their struggle to transform their economy from a backward centralized command economy inspired by a form of prototypical progressivism, or "scientific socialism" as the communists boasted, to a market economy to become, as one economist put it—"Europe's growth champion."[29] Obviously, a crucial role was played by the radical plan that steered the transformation, but it is could not have been as effective as it was without the hard work of millions of Poles. And undoubtedly the mutual support of spouses played a largely unnoticed lubricant to that exhausting effort. I can well recall the blood, sweat and tears that poured out of Polish families at that time attempting to get ahead or simply make ends meet—yes, I am speaking in metaphorical terms, but just barely.

Like no other institution in the country the Church continues to promote family values in Polish society, among other means through religious education that has returned to the public schools. And despite criticism that this goes against sex education it should more accurately be said that it joins sexuality with moral values in a manner much needed but unfortunately not heeded in today's world. And family remains a strong value for Poles, regardless of age. For instance, according to the World Values Survey of 2005 91% of youth in Poland claimed that family is an important value in their lives – the highest percentage in Europe.[30] Recent surveys in the country confirm that a great majority of Poles feel that family is the key to happiness. Significantly, although the divorce rate increased in Poland shortly after 1989, it has by for the time being

partially leveled off and remains among the lower rates in Europe and marriage is still quite popular despite the alternatives. Nevertheless, the fact that in 2014 it was noted thirty percent of marriages break up makes the rate twice as high as in the mid-1980s. At about three percent of domestic couples in 2019, the percentage of Poles cohabiting or in common law relationships is also low by European standards.

However, family values by themselves—or, rather, even with the support of the Church—are hardly enough against a harsh reality. And so, unsurprisingly, despite its success at one level, the stress of catching up had enormous consequences at numerous other levels, and continues to have reverberations. Among other matters, the initial economic uncertainty and increased mobility which often shattered traditional familial support systems within Polish society in larger cities were quite possibly factors contributing to its current demographic crisis. Among other matters, this discouraged young parents from having more than one or two children. After they came to power in 2015 the Law and Justice party was the first government to take the demographic issue seriously, but it was only mildly and temporarily successful.

As the crisis deepens this phenomenon which is accompanied by an increasingly aging society will likely also hamper further economic growth. Demographer Mary Eberstadt argues a low birth rate is a key factor in restructuring the family in a manner which generates a substantial decline in religious practices.[31] While things have not gone so far in Poland, a clear distinction exists between the higher level of religious practices and accompanying worldview of older Poles who have experienced Communism and the younger ones who have not, as was most dramatically demonstrated in the feminist pro-abortion demonstrations late in 2020 which were accompanied by an unprecedented defamation of churches. These were affected by the political climate in the country but were indicative of underlying social processes.

There is also a change in the country concerning the broader outlook on the common good that is fairly typical in countries with a developed economy. As Sandel puts it, "Today, the common good is understood mainly in economic terms. It is less about cultivating solidarity or deepening the bonds of citizenship than about satisfying consumer preferences as measured by gross domestic product." This has negative effects on relations and how people relate to each other at different levels, since among other things it leads to "an impoverished public discourse."[32] Which in turn undermines attempts at reaching even low levels of consensus—often accompanied by polarization—necessary for the common good.

Social psychologist Janusz Czapinski compared the two major phases that he distinguished in the development of Polish society after accession to the European Union to those famously described by Abraham Maslow in his hierarchy of needs for individuals.[33] Czapinski observed Poles had spent their early years in the EU dealing with their more basic needs, that is on advancing their sense of material wellbeing. Once these needs had been met to a substantial degree they turned to higher ones, such as augmenting their sense of identity and self-worth. In this new ambitious tendency there were also political consequences: during the seminal elections of 2015 it was the Law and Justice party that was more in tune with this change within the aspirations of Polish society ended up victorious. In other words, this political event was a democratic response to a very understandable national urge; nevertheless, it was at this point Poland's more complex and often negative relationship with the EU effectively began, especially at the political level.

The development to some extent extends Pascal Bruckner's insight expressed in *The Tyranny of Guilt*, that a "sobered up Europe" constantly obsessed with its earlier sins of colonialism is nevertheless "no less arrogant than imperial Europe because it continues to project its categories on the rest of the world and childishly boasts that it is the origin of all the ills that beset the world."[34] In this context, it would seem not entirely incorrect to claim that the EU's taking out their suppressed sense of global superiority on the presently weaker countries of East Central Europe can be understood as a manner of kicking the cat, so to speak. Although no doubt the "cat" is not altogether innocent.

Why is this so? For the historical reasons given above Poland and other countries from East Central Europe support the idea of the EU as a Europe of nations. Korab-Karpowicz maintains the importance of nations, states and their cultures as a key rather than obstacle to global diversity and solidarity. "Human beings can fully develop and reach happiness in conditions of freedom and the diversity ensuing from freedom," he states, pointedly adding: "The multiplicity of countries and cultures should be preserved. An imposed uniformity is contradictory to humanity's yearning for development."[35] Such genuine diversity constitutes a value in itself but also some notable successes in one national community can inspire others, and so we have another potential avenue for "inclusive identity."

Among other such related matters, we have the concerns raised in *The Paris Statement* of 2017. The authors—among them Roger Scruton, Remi Brague and other luminaries, of which Piotr Legutko was the lone Pole—claim that the problem Europe faces is not merely the poor construction of an EU superstate or the mass immigration of Muslims. It is also the peddling of an illusion; Europe has a false understanding of itself, the writers state:

This false Europe imagines itself as a fulfilment of our civilization, but in truth it will confiscate our home. It appeals to exaggerations and distortions of Europe's authentic virtues while remaining blind to its own vices. Complacently trading in one-sided caricatures of our history, this false Europe is invincibly prejudiced against the past. Its proponents are orphans by choice, and they presume that to be an orphan—to be homeless—is a noble achievement (#2).[36]

The overall vision in the statement concerning the EU largely corresponds with the political philosophy of subsidiarity, which—albeit originating in Catholic social thought—is incorporated in the Treaty of Maastricht that created the current instantiation of the polity.[37] It was the first direct reference to the principle in treaties. But the same article within the treaty also talks about creating an ever closer union. This latter idea is the mantra of the powerful unelected Eurocrat lobby of the superstate wannabe. And this, among other things, is what the above authors criticize—but they are like a voice in the wilderness.

The EU is becoming a transnational version of a cosmopolitan dream with roots at least as far back as the nineteenth century when it was partly embodied in an attempt to create a universal language and religion, among other matters. The language was even created in the Poland of the Russian partition, in Warsaw, where Ludwik Zamenhof developed the auxiliary language Esperanto, with the laudable goal of fostering world peace. The religion, the Bahai faith, was developed, oddly enough, in the Islamic kingdom of Persia. The Bahai faith, although successful to a degree and still with us, instead of achieving universalism and uniting the people of the world simply created one more religion. There is a certain symbolic truth here if we look at the results of the experiment of a universal religion and a universal contemporary polity. When we compare the fate of faith with the secular universalism of the EU, we see the helplessness and ineffectiveness of such a religion, since Bahias became persecuted in their homeland of Iran after the Shah was overthrown, without drawing much international attention to their plight. On the other hand, the EU elites, as Frank Furedi argues, tend to possess a paternalistic attitude toward East Central European national communities.[38] In other words, a vibrant national sovereignty is seen as an obstacle to the transnational state.

In *The Strange Death of Europe*, Douglas Murray expresses surprise at the degree that Europeans, especially the elites, hate themselves. He also detects a palpable sense of ennui in the continent: the sense that "life in modern liberal democracies is to some extent thin or shallow and that life in modern Western Europe in particular has lost its sense of purpose."[39] Nor in Murray's view does the largely reductionist message of science offer much hope, while contemporary high art offers little inspiration. Not religious himself, Murray complains that

most European Christian churches do not particularly help the situation since they have lost confidence in their own message and their religion has largely been reduced to a form of "left-wing politics, diversity action and social welfare projects." And so unsurprisingly they have either lost or have difficulty keeping their flocks. Murray is essentially describing what has been termed "Moralistic Therapeutic Deism," which consists of a watered-down religion. In other words, the various Christian churches have largely engaged so much effort in accommodating themselves to the times that they have little of their own to provide when the times themselves are the problem. What Murray adds is the observation of a perceptive non-Christian that confirms the phenomenon, while pointing out Europeans are not buying it. They are abandoning the Churches, but nothing has effectively replaced the hole that has been left where previously meaning was created: a fact that he bemoans. And in his *Madness of Crowds* of two years later the author extends the list of agents that through ill conceived "unconstrained" views challenge and hinder our societies in the striving for the common good.

The lost sense of purpose Murray intuits in Europe and beyond suggests the continued presence—possibly even intensification—of the existential vacuum that Viktor E. Frankl has indicated decades ago as a problem within modern societies, whose members consequently seek compensatory pseudo-values at various levels or resort to power in different guises and baser instincts when they cannot find fuller meaning.[40] As I mentioned in the introduction, Frankl was among the earliest moral psychologists that pointed to religion as a deep source of meaning and self-transcendence for the individual. The voice of religion, most powerfully represented by the Catholic Church in Poland, has historically guided Poles through their greater and lesser trials, and despite its problems continues to direct a good number of Poles toward a self-transcendent communitarian self, which is so vital to developing the common good. Will it manage to do so in the future? This is only one pertinent question impossible to definitively answer, but which is a key to the fostering of the vocation of the national community and with no salient replacement in sight.

The institutional Church has had its own crisis of authority of late related to the problem of pedophilia within its clergy. When the crisis initially broke out a decade earlier it seemed the Polish Church got off relatively lightly, but there were those who felt that the matter had largely been swept under the rug and no real measures were employed to solve the problem. The seminal year was 2019. Surveys in May of 2019 indicated a large drop in the authority of the Church in Polish society after a drastic documentary on the topic was aired on YouTube and attracted millions of viewers. The bishops quickly issued a contrite pastoral letter condemning the acts of sexual abuse of children by priests after this event.

Jarosław Flis claims statistically the problem is no greater in the Church than in other institutions dealing with the young and society at large, but the institution can lose a great deal of its authority within Polish society if it does not deal effectively with the problem.

On the other hand, besides the state itself the Catholic Church is the largest organization in Poland helping the needy. According to a report released by the Catholic Information Agency (KAI) in 2018, within the framework of the Church there are over eight hundred charitable institutions in the country which reach approximately three million beneficiaries. That is above and beyond those agencies that serve at the parish level, where, among other services, over twenty thousand volunteers are engaged in the parish councils of Caritas, which also function at several thousand schools. These are essentially at the beck and call of a substantial portion of Polish society. Not to mention the cultural centers that many of these parishes constitute, where they are often the only such centers in peripheral areas of cities or in smaller urban centers or villages. Moreover, when the Covid-19 pandemic struck Poland during Lent in 2020, while the churches were largely closed to the faithful by government decree to maintain the social distancing campaign, those faithful along with church organizations like Caritas were involved in a tremendous voluntary campaign to help those in need, not to mention buy food for those in isolation and medical equipment for the hospitals.

Naturally one of the controversial areas in a contemporary sovereign state has been the relationship between the Catholic church and politics in the country. This relationship is hardly surprising considering the importance of religion in regaining that sovereignty on the one hand and the fact that well into this millennium almost two thirds of Poles favorably acknowledged the relationship between Christianity and national identity—not the highest in Europe, when some of the Christian Orthodox countries are taken into account—but outstanding in a relatively large national community by European standards. So despite the fact that the constitution of the country passed in 1997 does not favor any religion the Catholic church has had the unofficial status of an "endorsed" church, obviously without the suppression of the rights of other faith communities. From the onset there existed a relationship of autonomy between the Church and state, yet the possibility of cooperation existed, which included the honoring of religious freedom, and thus it was an open medium for cooperation toward building the common good. But this relationship has soured somewhat in the eyes of parts of society, partially due to the rise of anticlericalism on the one hand, together with the more counterproductive elite European sense that religion is at best a private matter—the effect on community of this attitude is dealt with above. Since this split is along party lines and much of the mainstream private media, the fact

that now only one major party is more supportive of the Catholic church and happens to be in power motivates that media to hunt for any minor favoritism.[41] And so the Church is not infrequently the object of political manipulation by politicians on both sides of the divide: by those wishing to gain the religious electorate, and by those wishing to gain the growing anticlerical electorate. As one of the more moderate commentators, Tomasz Wiścicki, points out, despite the largely restrained stance of the Catholic church itself at this time, individual bishops and priests that support both sides of the divide provide fuel for the opposing media. Wiściski is also less sanguine than Flis if it comes to the mainstream media with its current bias letting up on the Church in matters such as pedophilia within its clergy even if the institution comes up with a good solution, and actually few institutions in Poland have made the effort of the Church to prevent the problem from continuing.[42]

Cooperation is not possible without a common goal, and thus we enter the realm of politics. Cooperation with a common goal creates wealth and well-being, which coordinates individual interests and directs the life of a political community. Thus it is essential to note that a political community is not merely a collection of individuals living on a particular territory but a society with intergenerational roots and common traditions that are the basis of a common identity.

As was evident to some degree in the example of Poles visiting cemeteries in droves during the All Saints' Day holiday in the last chapter, part of the role of religion in building community in Poland is through providing a near ritualistic dimension to historical memory. In numerous European countries, particularly those with lineages of a millennium of more, the Catholic or Orthodox church provided the first chroniclers of the histories of the diverse national communities. And in a place like Poland that lost its sovereignty for over a century up to the First World War the Catholic church regained much of its earlier role that had eroded in the Polish version of modernity through its support of that community. This was once more the case during the Communist regime, where historical memory was under attack through appropriation. During the occupation of Poland in the course of the Second World War completed after its end among other crimes the Soviets exported their falsified version of history to the conquered peoples, and systematically extended it through the subsequent satellite state of the Polish People's Republic right up until 1989. After the Poles regained their sovereignty it was not so easy to correct the damage. There was the matter of dealing with the monuments to "liberation" of the Red Army at that juncture that had been imposed upon the population. There was confusion in some communities, for instance, as to how to treat them. Among other things, restoring a

corrected historical memory was a priority. Much of it concerned the relationship between the Polish past and religion.

In 1966 one of the fiercest battles between the Communist regime and the Catholic Church for the soul of the Polish national community concerned the primary foundation myth of the Polish nation at a crucial anniversary: the millennium of the acceptance of Christianity by the first ruler of the united tribes that would shortly constitute the Polish kingdom. The rulers of the officially atheist state considered the baptism of Mieszko I at that time as a purely political event—the founding of the Polish state—and while the Church celebrated the birth of the Christian nation and rallied Poles to this fact so that the Communist regime vainly attempted to counter this religious significance through a purely secular celebration of the event. The advantage the Church had was that it did not have to deny the event's political significance but raised it to a higher level that gave meaning to the lives of Poles and aided in exposing the falsehood of their lives under a totalitarian state. That is the intuition behind Cardinal Stefan Wyszyński's political theology. The sad paradox is that in places like Canada where I lived at the time the Polish community in diaspora could celebrate the anniversary freely while Poles in their homeland had to fight to do so.

From the historical perspective, by accepting Christianity Mieszko, the ruler of the Piast dynasty who united the tribes making up Poland, certainly did gain political benefits. For one matter, his kingdom was spared the threat of eventual conversion by force on the part of the Holy Roman Empire, since with the ruler's baptism the excuse for conquest from that perspective was removed. Forcible conversion was a genuine threat. Quite simply, by the fifteenth century no independent pagan nation existed in Europe. During Mieszko's reign Christianity was likely limited to his own court and not much more.[43] Whatever the ruler's own stance toward the event the die had been cast for the birth of a Christian nation.

The political and religious significance of the foundational event was understood in the Middle Ages when Poland indeed became a Christian nation. Close to the end of the period, already during the rule of the subsequent Jagiellonian dynasty, the first comprehensive history of the nation was created by the scholar and historian Jan Długosz in his monumental history of Poland, written in the form of a chronicle. While his skills as a historian surpassed that of the earlier Polish or foreign chroniclers in Polish courts, he also included elements of hagiography or mythical elements in his history. Research shows that in fifteenth century Poland there was a sense of national identity present among the gentry, so the term nation was likely not used lightly by Długosz.

The political aspect of the head of the Piast dynasty for the history of Poland was not lost on the Polish Romantic poets, that is during the seminal period for Polish identity of the Partitions in the nineteenth century when sovereignty had been lost. Their interpretation of the significance of the Christian nature of Polish identity was augmented with the philosophy of "Your freedom and ours," in which the struggle for Polish independence was given a universalist impulse. More specifically, the Polish historical foundation myth feeds the messianic covenantal spirit. Thus the religious foundation myth merged with the emerging covenantal spirit, so important for maintaining a sense of national identity.

If the Romantic bards stressed the religious and universal nature of the acceptance of Christianity by the Polish ruler, almost a century and a half later when Polish sovereignty was again absent due to Communist rule, Cardinal Wyszyński concentrated on the sacred nature of Polish history initiated by the foundational event: "There is no greater continuity in Polish history than the continuity of the salvific stream of water from the christening font, which endlessly flows through Poland on the head, soul and heart of the Polish nation, from Mieszko to the small boy or girl child, whom the priests baptize."[44] Faith and fatherland are thus united.

Cardinal Wyszyński made his statement during a dark period in Polish history when the Church was one of the few lights available for the national community. Half a century later in 2016 the baptism of Mieszko was celebrated under radically different circumstances. In a post-Communist democratic republic the one thousand fiftieth anniversary of Polish statehood the religious significance of the event was no longer controversial. Unsurprisingly the president of the republic participated in the main religious celebrations of Mieszko's conversion. But in a pluralistic society with its divisions, the political situation of the country gave rise to its own tensions even if they paled in comparison to the gravitas of those of a half century earlier. Among other matters, since the Polish government was already experiencing problems with Brussels on account of judiciary reforms, the opposition parties ignomously boycotted the main celebrations.

Naturally many Catholic journals had special numbers devoted to the topic. Particularly pertinent for its evocative treatment of the event and its significance for Christianity in Poland was a special 2016/2017 issue of the yearbook *Teologia Polityczna*, simply entitled: *1050*, i.e. the anniversary of the event that was celebrated. The issue was introduced by two prominent Catholic public intellectuals closely connected with the journal: Marek Cichocki, a political philosopher and one time advisor to President Lech Kaczyński, and Dariusz Karłowicz, on the editorial board, a historian of ideas, among others the vice-director of the Warsaw Uprising Museum. The journal and the accompanying website brought political

theology to a broader Catholic public in the country and the special issue focused the seminal nation-forming nature of the relationship between politics and religion over time. A "gallery of Poles" and their times were presented, from the Piasts to the present, that added their own special ingredient to the relationship. In their pithy introduction Cichocki and Karłowicz define Polishness as a fusion of the Slavic element, the influence of Western classical civilization and Christianity: before these seminal elements came together there was no Polish nation, for which Mieszko's baptism was a crucial instantiation: "Through the sacrament, which united and animated the different elements, Poland came into being at once as a Catholic nation. At that time, 1050 years ago, the constant until this day shape of Poland's DNA was formed (understood in a cultural sense, and so common—at least as a reference point—even for non-Catholic and non-believing Poles)."[45] The authors continue that the sacrament had a greater significance than simply opening the way for Poland to become a member of the European community, which historians emphasize. A permanent relationship to the transcendental nature of our existence was initiated. This relationship has three clear features.

First, a double sense of history exists that is simultaneously political and religious. From the beginning Poland's fate gained the element of eschatological hope that added the transcendental point of reference: "And so in the Polish case politics in the communitarian dimension gained a totally exceptional character of a pilgrimage, from which it is not possible to reduce to any flat, materialistic dimension of history."[46] Second, Polish nationalism gains a universal sense through Catholicism, which excludes any possibility of attributing an absolute nature to Polishness. The authors stress the Polish distinction between patriotism and nationalism, as commonly understood, to which they attribute the role of Catholicism.

The authors concentrate a good deal of attention on the third sacramentally augmented feature of Polish politics: its inclusive nature. They claim the fact that since from the Catholic perspective faith stems from grace, freedom of religion is crucial to a sound political system. Cichocki and Karłowicz provocatively stress:

> If in today's debates we return to the image of Jagiellonian diversity with its multi-ethnic, multi religious and multicultural nature, then we must remember that Roman Catholicism facilitated rather than created barriers for it. From the Polish perspective a theocracy means an attempt at appropriating divine competence—it expresses the conviction that politics can impose faith. No state can be the ruler of the consciences of its citizens, otherwise it destroys the relationship of politics to the transcendent.[47]

Here it is worth pointing out this argument basically places the Polish national community within the best European tradition with its Christian roots. As the authors of *The Paris Statement* put it: "The true Europe affirms the equal dignity of every individual, regardless of sex, rank, or race. This also arises from our Christian roots. Our gentle virtues are of an unmistakably Christian heritage: fairness, compassion, mercy, forgiveness, peace-making, charity. Christianity revolutionized the relationship between men and women, vaulting love and mutual fidelity in an unprecedented way (#10)."

The sacred foundation myth and the Golden Age, as we might call the Jagiellonian period, are in this manner placed on the same continuum by the authors. As is evident, with the right reading this aspect of sacred memory also augments Han's "including identity," a point we will look into before concluding this discussion.

After the Second World War when the borders were shifted and populations transferred, including Poles from eastern parts into the new borders, as well as through the Holocaust with the loss of most of its Jewish population, Poland lost most of its larger national minorities and became a largely mono ethnic national community. Among the small groups of historic ethnic minorities currently present in Poland worth noting are descendants of Tatar mercenaries from the fourteenth century. They were the largest free Muslim population in Europe for some centuries. They also fought courageously against the Germans during the Second World War, and when the communists took over, a number of them left the broader historic lands of the Polish Lithuanian Commonwealth to settle in the new narrower borders of Poland where they intuited communist control would be less of a burden.

At present among the Tatars strongest cultural centers is in the small town of Kruszyniany in north-eastern Poland—a place they were given in the seventeenth century as payment for their services during a war of the period. Tourists frequently visit the Tatar museum and they are told that Charles Bronson is their descendent. So when one of the protagonists of the Native American produced motion picture *Smoke Signals* of 1998 tells his friend that his father looks like Charles Bronson, there's a good reason why that might be so, considering the Asiatic descent of Native Americans. But these Tatars will also tell you that while they value their traditions and culture they feel themselves to be primarily Poles.

Among the public faces of the group is Selim Chazbijewicz, in the recent past an imam for Muslims in Gdansk, and for a time president of the Association of Tatars of the Republic of Poland. He is a political scientist, columnist and poet. In politics he supports family values. Since 2017 he has been serving as an ambassador to Kazakhstan. Asked in an interview if he thought that the Islam that

the Tatars in Poland practice is fairly moderate he went beyond the common assurances of the pacific nature of genuine Islam and admitted that Islam was in need of reform to be able to cope with the modern world, especially those strains connected with the radical Wahabbi movement. He contrasted this with the ability which the Tatars exhibited for centuries to enter into close relations with the Christian majority and develop internally. As a leading member of the Joint Council of Catholics and Muslims he also summarized his experience in interfaith dialogue with Christians: "It is easiest to conduct dialogue with the Catholic Church. Protestants, similarly to us [Muslims], are too dispersed... The Catholic Church has historical experience with Muslims that other Christians lack. The Catholic Church simply knows how to talk with us."[48] During a meeting at a Dominican church in Lublin in September 2011 Chazbijewicz stressed the unique nature on a European scale of the Day of Islam that the Catholic Church in Poland celebrates, and claimed that such efforts are influencing the attitude of much of the Muslim community toward Christian Poles. The Day of Islam follows the ecumenical Week of Christian Unity, which is preceded by a Day of Judaism.[49]

Speaking of Judaism, although on account of Poland's stormy history that includes the Holocaust the once large national Jewish community is a shadow of its former self, the wealth of that history makes most of them identify with the country. At the institutional level this is given expression in the Polin Museum established in 2005.[50] At a personal level, Stanisław Krajewski represents a strong direction that has evolved in recent decades. Among other things he has been active in Christian and Jewish dialogue at different levels for a lengthy period and has left a record of this part of the relationship in his book *Poland and the Jews*.[51] Moreover, the community has a number of its own journals. More recently, the blogosphere has brought a grassroots organization, the Forum of Polish Jews, in contact with a much larger group of their non-Jewish countrymen than it was possible in the past. Their informal spokesman, Paweł Jędrzejewski, responsible for Judaism in the group's own website, participates in national debates in the influential Salon24 blogosphere. As a conservative living in America he warns Poles about woke ideology and its devastating effects on society. He defends Christian Poles against inordinate accusations of anti-Semitism, stressing what he considers the biased political nature of some of these accusations.[52] He also defends Poles against what seems to be a growing narrative of their co-responsibility for the Holocaust.[53] Jędrzejewski stresses how important it is for Poland to remain a Christian country. For instance, he praised a conservative bishop for his biblical approach to conservation, and he criticized the Chief Rabbi of Poland for defending an LGTB activist, since he pointed out activists from woke ideologies

are actually not discriminated, but rather on the offensive against traditional values and have powerful backing.[54] He also points out Poland is among the safest countries for Jews in Europe and much of the world.[55] Of course these opinions are not fully representative for the Polish Jewish community, rather they are indicative of their diversity.[56]

Looking at Poland as a Catholic country, it needs pointing out not all Catholics are ethnically Polish. There are Ukrainians, which have both Orthodox Christian and Ukrainian Catholic members, in other words the latter celebrate an eastern rite Catholic faith. Among the larger historical minorities that also have a large number of Roman Catholics are the German and the Roma communities, the latter likely with the largest number of Roman Catholics who are not ethnic Poles (which does not prevent them from being the group that draws the greatest amount of negative feelings in the country). Whether this will remain the case depends on what immigrants settle in Poland in the future—their number may be relatively small now, but as the country is a member of the European Union, the situation may slowly change—along with the religious mix they bring with them. Currently the immigrants come from various religious backgrounds and are largely presented in the media by country of origin with rarely a mention of their religious background. For instance, there is little information whether the few Nigerians settling in Poland are Muslim or Christian, and Poles are not particularly interested. Immigrants are often enough not entirely representative for their home populations with regards to the religions their members hold, so likely the Nigerians in Poland would rather be mostly Christian. Unfortunately, for the general public race plays a larger role for the reception of African immigrants, and so racism is a problem, although rather declining. One might add the highest profile Nigerian immigrant in Poland in recent years was John Godson, a Protestant minister who was a member of the Polish parliament between the years 2010–2015, and who, among others, was active in a committee on the persecution of Christians in the contemporary world: something which Polish Christians already have behind them for some time, but is quite topical for an African Christian. Bawer Aondo-Akaa, the son of a Polish Catholic mother and Nigerian father attended an Independence Day parade in 2018 where there were a few extreme nationalist banners. When a Dutch politician making no distinctions called the entire parade fascist, this son of an African immigrant who declared himself a Polish patriot intended to sue the foreign politician for defamation. Sometimes analogies with Polish history that immigrants or foreign students find with their own histories make Poland attractive, such as Kurds who are struggling to gain their own nation state and greater rights in their indigenous home countries, and thus feel some affinity with Poles.[57]

Among the contemporary Asian immigrants to Poland the Vietnamese seemingly hold an insignificant place among these immigrants as a whole. And yet they are in part connected with the Polish national community's past in an unusual way that not many are aware of. After the Vietnamese war with the United States the nation was indebted to the member countries of the Soviet Bloc that had been forced to support it financially. So a number of Vietnamese worked on contracts in communist Poland in which part of their salaries would help pay off their country's debt—like all such workers of that time in communist countries their families were quasi hostages in their homelands to make certain they would return after their contracted work was finished. Poland made a positive impression on a good number of these Vietnamese and some of them are among the immigrants that have now settled in the country. The community is now the second largest of their nation's immigrant groups in Europe. Nevertheless, they have a relatively low profile in the country, known mainly for their restaurants—part of the growing diversity of cuisine now available. A theatrical film was made about the Vietnamese in Poland by Marika Bobrik, a Japanese director who has lived in Poland for a lengthy period and studied filmmaking here. However, due to be released in 2020, unfortunately *The Taste of Pho* never made it to the screens on account of the pandemic and its restrictions, and was likely only seen at an Asian film festival.

It is hard to say to what extent the comparatively sizeable Vietnamese population in Poland has a greater proportion of Buddhists than Christians. As of yet the Buddhist group is not very organized, although it has invited Vietnamese monks from France to assist the community. Often enough Buddhist parents send their children to Catholic religious education in the public schools in order for their children not to stand out from the majority. As concerns the smaller group of Christian Vietnamese, suppressed in their own country by its communist regime, the community found a receptive space in its new host country. A missionary order runs a center for immigrants in Warsaw where many of the Vietnamese come and attend masses. Naturally not all the Vietnamese Christians participate in such missions; some are more isolated in smaller centers, while others drift into religious indifference amid the struggle to get along in the new country.

The question of immigrants in Poland raises the problem of the common good in relation to multiculturalism. There was also the problem of the European immigrant crisis in 2015, but overall the question is not all that pressing at the moment, since there are few members of historic national and ethnic groups in present day Poland and new members are not so numerous as of yet. The largest group of foreign residents in Poland are Ukrainians. Their situation resembles

that of Poles who often sought greener fields in wealthier EU countries, predominantly the UK when it was still a part of the union, and where many still remain to this day. The situation of the Ukrainians is different in that most arrive on work permits which are difficult to transform into the highly desired permanent residence status.

And that is proof that Poland is becoming more attractive to immigrants and slowly they are arriving. Rabbi Jonathan Sacks, for instance, in his book *The Home We Build Together* of 2007 criticized the dominant approach toward multiculturalism in his native Britain that essentially isolates the immigrant groups and the host society depriving both of the notion of cooperating toward a common good. It would be wise on the part of Polish decision makers to heed Sacks advice when the time comes. The example of the Tatars above gives a fine example of this—a fruit of the Jagiellonian tradition. And it is necessary to be cautious and realistic. Robert Putnam has produced research showing that neighborhoods with a number of ethnic groups create less social capital—this problem is rarely brought up in discussions of multiculturalism, and though immigrants are often necessary, realistic approaches must be taken so that the no go neighborhoods present in France are not duplicated.[58]

There are also cultural aspects to consider in a potentially more multi-cultural Poland. Luma Simms, an immigrant to America from Iraq, expressed her dilemma upon moving to her new homeland: "I have found assimilation to be more of a revolution than an adaptation. In some sense I had to 'revolt' against who I was before, in order to enter into a new social order." She adds an important point, "A defining feature in the eyes of the immigrant is that [Americans] have an anti-family culture; the cost of assimilation into this culture seems too high."[59] Significantly, Gurinder Chadha's film *What's Cooking?* (2002) presents an immigrant family in Los Angeles from Vietnam that is quite distressed with what is happening to its cohesion, as the young enter the dominant highly individualistic consumerist culture. At least at present family life is valued in Poland, so such immigrants would find a rather congenial port of call in the country—which some on occasion have praised. Moreover, Poles have gained somewhat in self-confidence, so they are not as afraid of immigrants coming to the country as they were earlier.

Returning to the question of religion together with foundation myths and beyond, Marek Cichocki deals with a problem related to this in one of his most recent books, *North and South: Texts about Polish Culture and History* of 2018, where he reflects on the philosophy of Polish and European history.[60] He starts the introductory essay with the observation that so many Poles are placing their hopes in a unified Europe, which is not a problem in itself, but can nevertheless

be an excuse for not examining themselves at a profounder level. Moreover, he is critical of the present manner of Europe's unification which in his view is a rather shallow process that is overly horizontal lacking a vertical religious dimension. Cichocki argues Europe in its deepest sense has what he calls a north south vector which was largely lost in the Enlightenment. He explains this symbolic orientation in that the origins of its civilization go back to the creative encounter of the barbarian peoples, that is the north, with Roman civilization—the south. This led to the conversion of the barbarian peoples which transformed their destructive force into a creative form. Here in a manner he extends the foundation myth of the Polish ruler to include the "conversion," i.e. the transformation that accepting Christianity incurred. What was particularly meaningful in the conversion process was the impetus Augustine gave it through overcoming the destructive force of Manichaeism. The influential Manicheans believed in the reality of evil as a semi-divine force, while for Augustine evil is nothingness. Cichocki contends overcoming the nothingness of evil was a seminal factor in turning destructive pre-Christian forces toward the good. On account of their conversion and self-examination each of the barbarian peoples including the Poles discovered their own version of the good, which resulted in the variety of the good in Europe. Conversion directs a people toward the good. Conversion is closely related to self-scrutiny, which is a key element of moral memory. Thus in one way or another the problem of conversion is constantly present. One might argue that the contemporary culture wars with their bipolar judgments approximate a neo-Manichaeism, among others through their loss of the sense of human imperfection that we all share and thus the need for forgiveness. In his *The Madness of Crowds* of 2019 Douglas Murray discusses that issue of the lack of forgiveness on the part of contemporary elites for their opponents, as well as the remorseless permanent memory of the internet.[61] Without the "faculty of forgiveness"—which Douglas brings up—there can hardly be a more stable common good, since errors are always being committed in one form or another.

As mentioned, Solidarity was a key to overcoming communism, both in Poland and in part throughout the Socialist Bloc. Even further abroad there was a sense of the "end of history" at the Cold War's optimistic conclusion. Not only social scientists were caught up in this optimism. Alice Ramos reflects a religious hope that was held high shortly after the end of the Cold War: "past the first decade of the twenty-first century it is possible we are at the threshold of a new civilization where each person, through an interior conversion such as that of the prodigal son, can help bring about a civilization of interconnected persons, who are a moral support for one another, who reflect the understanding and love of

the supreme communion of persons that exists in God, and who thereby corre-spond to God's creative and salvific love."[62]

Returning to Poland, in such a large movement as Solidarity there were divi-sions, partially kept in check in light of the greater cause. Some of these resur-faced in greater strength not so long after sovereignty was regained. Moreover, some of these divisions also marked a different approach to religion and com-munity, and thus have some impact on how the common good is understood. Like in many societies religion has become a matter of personal choice in the country. This also includes a selective approach to matters of religion and faith. And so while the strength of religion in Poland confronting communism was in its communal nature, a much greater emphasis on its individual nature is present today. Which does not mean that the individual approach was completely absent at the time of Solidarity. A former Solidarity activist who is now an advocate of a form of religious individualism is Jerzy Surdykowski, most recently author of *In Hope of a Sensible World* (2020), where he attempts to combine reason, scien-tific knowledge and—it must be admitted—a deep Christian faith. But this faith is highly personalized, and he feels that this aspect is simply the way things will go for people of faith in the country, and sociologists largely prove him right regarding younger religious Polish Catholics. Surdykowski does not reject the Catholic church but hardly sees it as an authority. Nevertheless, he recognizes the sacrament of the Eucharist as extremely important, which seems to be some-thing of an inconsistency in his personal belief. What is noteworthy here is both a high individualism and solidarity in what for many would seem a fragile syn-thesis. This is religion at a crossroad, and to the extent that in the writer's genera-tion it was more common for an elite, for the next generation, especially in urban centers, it is much closer to the norm of those who are still religious.

And so we see this in another example of such a religious stance comes from a much younger Pole. Born during the Solidarity period, Jan Komasa is a Polish film director, screenwriter, and producer best known for directing *Warsaw 44* (2014)—a film about the Warsaw Uprising—and *Corpus Christi* (2019), which was nominated for the Best International Feature Film at the 92nd Academy Awards. The film depicts a rascal from a reformatory who wants to become a priest, yet realizing he would not be accepted in a seminary on account of his criminal past, he takes the opportunity when it arises to pretend to be a priest in a small town. In his review of the film for *National Review* Armond White claims the film is more interesting than the strongly left-leaning South Korean winner of that award, that is *Parasite*. As he puts it, the latter film "regarded moral de-pravity as farce, which *Corpus Christi* does not."[63]

That the Polish film has a highly moral nature is certainly true. White points out that despite its depiction of a "contemporary miasma," which the protagonist who pretends to be a priest represents, the film convincingly presents the divisions in the small town society and the priest's commendable efforts at overcoming this confrontation. White notes, "The first homily is haunting," from which he then quotes these lines:

> Know what we're good at? Giving up on people. Pointing the finger at them. "Forgive" does not mean forget. It does not mean pretend that nothing happened. "Forgive" means love.

The Polish viewer has a good idea of which divisions in the larger society Komasa is hinting at despite the more literal ones of the narrative, and the filmmaker does indeed demonstrate a good deal of sensitivity and attempts to build bridges. He also generally notes the importance of religion for the community, although with a certain ambivalence. For one thing, it has been pointed out that Komasa's theology is quite shallow. Significantly, when the protagonist faces the congregation during one of the sermons, he takes the automatic pilot and clicking it slides a screen over the painting of Mary and Child next to the altar, a sign of its alleged inadequacy for the problem at hand. One of the Polish reviewers notes the priest behaves like a psychologist "coach" more concerned with the psychological condition of the parishioners than their souls. For all intents and purposes God is absent from the film. What this essentially means is that intentionally or not the film reduces religion to Moralistic Therapeutic Deism, the first step to its redundancy. Since Komasa is from a larger urban center, this might be a sign that this transitional vein of religiosity is taking hold in such centers. One might put it that the cure is in some ways worse than the illness of religion in its present state.

Whatever spiritual sustenance such religion gives its adherents at present, in practice it does little to build community, despite such a message in the film. That makes the vision presented by the filmmaker as somewhat naïve. Admittedly this approach at least acknowledges the importance of religion for Poles. But that is obviously not the only trend occurring in Polish urban society, much of it more sobering. In one of the interviews he gave after the publication of his *The Madness of Crowds* of 2019 Douglass Murray noted how it seemed not long ago that a number of the formerly hot issues such as feminism or attitudes toward sexual minorities that had come close to reaching a consensus within Western democracies all of a sudden exploded in so called identity politics beyond any plausible solution. Let us reflect on what this implies for a moment; worth noting, for instance, the variety of approaches within feminism included an ethics of care that among other things had supported efforts to build community.[64] This vein seems

to have little support at present. In Murray's book he partly blames the virtu-ally uncontrollable internet and social media for the negative new phenomenon. But that is rather augmentative than a source of the phenomenon. Frank Furedi writes about how members of contemporary society sufferer anxiety from the breakdown of community which leads to an individuation suffused with anxiety over problems of identity. The political aspect of this stems from the sense of vulnerability and entitlement for protection many feel.[65] Here we have a partial sociological explanation for the narcissistic cult of authenticity along with an accompanying current socio-political phenomenon affecting so many western societies.[66]

The above phenomena are certainly not helping the family, which while main-taining some ground, is less stable than it has been. What that means at a societal level is higher polarization, observed for some time in wealthier societies. For one of the skills that build lasting relationships is conflict resolution. And when that skill diminishes at the level of the basic societal unit, it suffers at the level of the larger communities, up to and including the national community.

The above together with the underlying narcissistic cult of authenticity it aug-ments have not escaped Polish society, as the national community has reached the peripheries of the international elite—which still represents a high standard of living. Thus the forces that break up community and subsequently diminish the capabilities of creating the common good are more powerfully at play. Among other matters, the narcissistic cult of authenticity Han describes rejects sociability and politeness, effectively leading to the brutalization of society. One might add the difficulty young people have in finding life partners. At one level this stems from young women often becoming better educated than men of their age and the effect this has on their worldviews. This will either result in a higher number of singletons or fragile relationships; not to mention a rapidly aging so-ciety will continue along the downward spiral of even fewer births. Significantly, something as seemingly unimportant as the fashion for tattoos mentioned above as well as—considering the public square—crude and brutal public demonstra-tions are all evident in Polish society at present, symptoms of an atomized so-ciety as Han would put it, or more accurately a significant segment of Polish society. These raucous public demonstrations come from both the far right and left, coming in increasingly larger waves and more strongly supported by the younger generation. In a consumer society this adds up to the phenomenon that in symbolic terms through self-absorption we consume ourselves. This trend is gaining momentum as the contribution of religion and its festivals to the na-tional community—despite some resilience—diminishes.

Are there any signs of hope? Some. There is a relatively new tradition, not much more than a decade old, which symbolically honors the old and builds the new: the revived Feast of the Three Kings. As a strictly religious holiday it has an old tradition in the Catholic liturgical calendar known as the Feast of the Epiphany, but as a renewed national holiday—it was likewise a national holiday in prewar Poland—it is quickly becoming transformed without apparently losing its roots. If, according to Han, religion plays an important role fostering rituals that build community, it also promotes their heightened form in festivals, which imply rest and leisure that through their circular treatment of time respond to the profound fact that "humans regularly feel the need to unite."[67] The revived Feast of the Three Kings is just such a festival. Han likewise points out such festive rites unite people in a manner that equally large gatherings of what are essentially consumer events cannot.

The holiday is connected with the venerable European tradition of the Twelve days of Christmas, which it concludes. To some extent the holiday's close relationship to Christmas obscures the fact that the biblical narrative on which it is based refers to different dimensions of religious experience than those associated with the dominant traditional holiday. In Christmas, through the Incarnation the Transcendent is personalized, and quite naturally the family is at its center. A popular Polish carol treating the theme at the heart of the new tradition has the lines: "The Monarchs are dauntless in their journey, they hurry on to Bethlehem." As noted already, in the Poland of today the dangers and distractions challenging one's faith are certainly present and range from the trivial to the substantial. Not to mention it is encouraging that such a festive religious holiday has grown in the face of a public sphere that hosts an elite emerging from a meritocracy that supports a substantial and even aggressive anticlerical culture.

The public face of Christmas in Poland is the Crèche—still set up in a good number of city and town centers at Christmas time—evoking joyful and communal contemplation; for the Feast of the Three Kings it is the parade: a symbol of a community in motion. In the case of Poles who have been undergoing a period of transformation with no early end in sight, they themselves are a people in motion. Moreover, the parade is inclusive. Everyone can join in—become part of the retinue—and be both audience and performer in the public ritual. Already in 2013, the fourth such parade in Warsaw attracted fifty thousand participants. And, in a similar fashion, each year more and more cities organize the event, while its organization remains largely grass-roots, supported by the Church. Just before the pandemic broke out, in 2019 such parades took place in hundreds of cities and towns. And on account of its second wave in 2021 the parades took

place in virtual reality. Like everything else the eventual coming out of these restriction will be a trial of the endurance of this phenomenon.

For now we can say the parade emanates from the folk religion tradition of the procession, but is effectively a festival. It includes elements of street theater and develops numerous local embellishments. Festivity is a much needed element in Poland's public sphere. There can be little doubt that times of celebration— a key element of a culture of leisure, which Han notes is missing in the neoliberal order—are important for fostering community. Moreover, a robust culture of leisure has an important implicit religious dimension: "culture and leisure mean that we accomplish the highest purpose in creation not in necessity, but in delight and freedom," stresses an American Catholic philosopher.[68]

Dariusz Karłowicz, a political philosopher who was one of the people instrumental in reviving the tradition, quite early on claimed that while its success surpassed the wildest expectations of the organizers there was never any doubt of that the festival would succeed as such. He speculates on what are the roots of this success despite the advancing secularization of the country. Karłowicz wondered whether or not it has anything to do with the inner journey the Wise Men of the East symbolize:

> Perhaps light on this unusual phenomenon is thrown by that inner voice postmodern culture calls the conscience? … Or maybe it concerns the experience of the frail nature of reality? The need for Hope? Faith? Despair? The desire of salvation and immortality? Of a road that is always from afar, of a "freezing journey" at "the worst time of the year," of such a journey which is undertaken against all the odds, and only in order to see for oneself, to bow low, and then to never be able to return home the same way.[69]

In Karłowicz's thoughtful reading the narrative at the heart of the revived holiday focuses on the journey—or rather pilgrimage—of the community toward the Truth, despite the dangers and sacrifices involved.

It is in a person fulfilling his or her vocation that it can be said the good approaches a transcendental. A vocation is a calling: where does a national community's call come from? At one level both from within and beyond the community: from within through its self-understanding, from without at the very least through its deeper relation to its neighbors and furthermore to humanity. At that juncture, when diligently approached, the limitations of the national community are no longer boundaries but starting points towards a form of self-transcendence. Together these sources work for the nation to create its own beauty which it shares through its culture and art and through its members to journey however awkwardly and with a greater or lesser number of detours

toward the truth that potentially unites us all. We will also look at a nation's journey more in depth in the next chapter.

The good essentially starts its journey in the home and finds its broader fulfillment in the national community through which humanity itself is enriched. These are not the only paths to the common good but they are crucial. Serious impediments to that seminal journey are the threats to the family both in Poland and in so many other national communities as well as the powerful contemporary barriers that need to be overcome in the struggle to create the common good within them. And the struggle is becoming more intense while the light at the end of the tunnel is flickering but it is not out yet.

# Chapter 3  Truth and Meaning:
##           A Pilgrimage Toward Wisdom

Howard Gardner argues the three transcendentals are conceptually distinct from one another, and so "each must be considered on its own merits."[1] While it is true that something can be true without being beautiful and vice versa, our search for meaning through and with truth, beauty and goodness requires all three to be on board that ship that we travel on to that special port of call of our heightened humanity, and to interact whenever possible. For instance, being honest is a good that rests on our being truthful. One of the ways we find meaning is by looking at ourselves and the world around us as honestly as we are capable of doing. And intellectual honesty further requires us to acknowledge the limitations of our ability to plumb the truth, which does not excuse us from making the effort.

In likely the best known Augustinian sense a pilgrimage is a journey toward God, the only source of true rest for our souls. This implies that life on earth for a believer is essentially restless except in moments of epiphany. If we consider truth as a goal as much as a reality then it is also in truth that in an analogous manner we eventually "rest" after a strenuous journey. There are of course scientific or mathematical truths and the like, where a degree of firm ground exists, but those truths are either above us and beyond the reach of most of us mortals or below us so that we need not deeply consider them. As necessary as they are—without their certainties, for instance, we might be afraid to step into an elevator, despite its technical complexity we hardly ever consider—they are not what give our lives their fullest meaning. The reliance we often enough place on such truths is gently mocked by Hanna Fry and Thomas Oleron Evans in their book *The Indisputable Existence of Santa Claus: The Mathematics of Christmas.*[2] The implied message is that among the most important truths are those that lead to the good life. And the imagination with its kinship to beauty can be the source of such truths even when—or especially when—they cannot be taken literally.

And so if the transcendentals are something you live as much as ponder, and this is likely to a greater degree so in the case of the truth, then seeking truth is a form of pilgrimage. Shall we ever really rest? The banal answer is that we must continually be on the move toward the truth. But where and what are the epiphanies that allow for periods of deeper solace or renewal during our efforts? Perhaps it might not be possible to fully answer those questions, but it is also important to have some idea which direction to take. The truth—or truths!—that

moves us closer to meaning and a fuller humanity is related to wisdom, and that is an important point of departure.

Let us begin at the beginning, with the conscious self—the "I" that directs us on our journey. It has been astutely suggested this consciousness has been "coaxed and coached" into us, usually by our nearest and dearest at the earliest stage, that is our parents, who instill within us not only an awareness of ourselves, but also—as Walter Ong puts it— "into an awareness of the rest of the actuality around [us] impinging on [ourselves]."[3] This awareness, however, changes over time with various consequences, even as to how we relate to our own earlier stages of awareness.

Truths with the most personal meanings often direct us toward other people. And for those of us that have, in a sense, been reborn—in my case there was marriage, which is most definitely a form of rebirth, as well as moving to Poland from Canada, which despite my roots in the country through my parents was a new world—there is eventually something of an ambivalence that is felt toward the old world with its people and how they affected us.

On the one hand, the issue is relatively straightforward and quite positive. In Jewish spiritual tradition we come across what is known as *midrash*: "the act of gazing into an old text and seeing something utterly new."[4] The old life is certainly an old text, and the harder we gaze at it the more we find new meaning. But this process has its bittersweet side.

A line in "Big Yellow Taxi," a popular Joni Mitchell song from 1970, strikes a hard note: "Don't it always seem to go, that you don't know what you've got till it's gone." A truism, of course, with the tendency of truisms to simplify matters. But truisms also potentially frame truths that at some level are close to people and direct them toward meaning. What we've "got" in this case is often other people in our old life who were somehow close to us and whom we learn to understand more fully over time, but time removes those same people from our reach so that perhaps we cannot share that deeper understanding directly with them. And this will be my point of departure in looking at truths that give us meaning.

It is hardly surprising that my settling in Poland and learning more about its culture and history gave a deeper insight into the Polish community in Canada from which I came. This to some extent brought that community closer to me, while the rest of Canadian society seemed to recede: partly on account of its comparative shallowness—at least in more general terms. Toward the end of his life writer Anthony Burgess claimed in an interview that World War II validated Augustine's view of fallen human nature, and thus he accused the prewar Bloomsbury group of Pelagianism with its overly optimistic view of human nature. One can hardly make such a bold statement about the effects of the highly

different historical experience of given societies, Polish and Canadian, in this case. But some of the differences that can be determined between them no doubt stem from the hard knocks that the first society has undergone and the relatively easy life of the other. And so I do not think it would be too far off the truth, in Sowell's terms, that an "unconstrained view" in which the above optimism takes hold of a fairly influential group within it, believes that Canadian society can be molded in virtually any direction it desires and at times that direction is fairly dubious. But at least to some extent the cause of this is related to the society as a whole—quite fortunately—having been spared the hardest knocks of history. Robert George, who has among other things served for a period as chairman of the United States Commission on International Religious Freedom, has of late written of his homeland, the United States: "We live at a time of great moral confusion,"[5] and rhymed off a great litany of woes to a morally sensitive human being. It is difficult not to sense that many of the same problems also affect Canada.

Whereas in my new homeland I live in a national community that due to the harsh experience of history implicitly senses or at least is partly shaped by Burgess's wisdom concerning fallen human nature that to a greater extent complies with a more constrained view that Gierycz notes. More down to the level of personal memories, my increased knowledge of World War II, together with my current membership in a national community where the memory of that catastrophe is far more alive, likewise casts greater light on those members of the Polish community of my youth who were veterans of that war. Among them were my own father and the man he chose to be my godfather.

Like not a few war veterans my father was fortunate to be alive, but in the case of my godfather it was truly a miracle he was alive. As a child and a young man I just assumed his wartime experience approximated that of my father's. It was only much later when I was already in Poland that I learned he was a survivor of the Warsaw Uprising, where the Nazis crushed the desperate Polish underground army's uprising in the eponymous city the summer of 1944 and then destroyed it, also killing much of the civilian population in punishment. My future godfather survived one of the skirmishes where most of his comrades were killed, after which he was taken as a prisoner of war to Germany, from where he emigrated to Canada after the war's end—and his and my father's Poland was fully occupied by the forces of the Soviet Union.

It was from the clutches of the Soviet Union that my father was released when the Germans foolishly attacked their powerful ally. At the onset of the war the former had occupied the large portion of eastern prewar Poland in which he lived as their share in the unholy alliance that together crushed and occupied a

valiant nation. The Polish army which was formed once the Soviets were "allies"—commonly called Ander's army after the general who formed it—then left Russia and through a circuitous route, initially through the Iran that bordered on the USSR, went on to join the British Army in north Africa and continued with it on their Italian campaign. Despite the numerous films dealing with World War II, that campaign was largely ignored in popular culture, so it is not too familiar outside of Poland and Italy at present.

Somewhat paradoxically, it was likely in Russia where young former Polish citizens like my father were absorbed into the Red Army that he faced greater danger from the horrendous treatment they received than in the Italian campaign where he served as a chauffeur to officers and was not directly at the front where so many Polish soldiers died, especially at the seminal Battle of Monte Cassino. This much I more or less knew from childhood with the family lore augmented by some additional reading. But details such as the treaty that enabled the formation of a Polish army on Soviet territory, or the crucial fact that that army decided to continue fighting in the Italian campaign even when they learned that Poland was not likely to regain its independence after the war, I learned when I came to Poland. By then my father was no longer alive.

Of course history is much more meaningful when it concerns those who are somehow close to us. Here my godfather was engaged in the hopeless fight to regain Polish freedom while my father was part of the effort where Poles fought for the freedom of the rest of Europe when the impossibility of their own homeland regaining its own freedom was virtually a foregone conclusion. "Your freedom and ours" was their motto: one that served Poles for generations. But to make matters worse, no good deed goes unpunished: despite their efforts in serving the rest of Europe, their homeland would nevertheless lose its sovereignty for an additional half century, and many Poles would live in Diaspora. On the other hand, the primary perpetrator of the crimes and atrocities against Poland and so many other nations and ethnic groups, most notably the Jews, would gain the Marshall Plan and regain its status as a world economic power, while Poland was left to the mercies of a totalitarian state, with its—among other things—"scientific socialism" and a centralized command economy that would leave it far behind countries to the west of it that were far less destroyed in the same war. Not to mention Poland would only receive partial reparations from that primary aggressor.[6]

Some of this I understood as a child and young adult, but one thing which made it more difficult to relate to these men and not a few women who also ended up in Canada was the fact that those experiences left deep scars on them, which were not very well understood by those of us who were born in Canada at

the time. Now, thanks to progress in psychology, we have a better grasp of post-traumatic stress disorder and how it affects people, including their personalities. And war is a major cause of the disorder. This was partly intuited but neverthe-less less evident at the time for many of us, including myself. To give one ex-ample, painful memories of the war were often recounted by the veterans during small gatherings and were drowned in alcohol. This latter aspect put me off at the time, now I wish I had paid closer attention to what was said.

I hope I have shown such memories are more than mere nostalgia. Obviously mine have their specificity, but they are hardly unique: all sensitive and not so sensitive human beings have their share of early memories. Many are far more dramatic than those I have recounted. To what do they amount to besides per-haps opening us up to a broader range of perceptions and cultural experience, as important as that is? At their deepest level I am convinced memories are not just a duty to those who gave us life but also a form of what could be called com-munion with them. This relationship is related to the mystery of existence—the past creates the present and these people of memory are as real as we are while at some metaphysical level we are as unreal as they. If we take meaning away from them we ultimately take meaning away from ourselves. We have a choice: be-tween nihilism and meaning—which might further extend to or be augmented by religious belief in some, and for me this is the case. At any rate, this is not simply a philosophical question but also how we understand the truth of our being: although it is philosophical in the sense of lived wisdom which affects us all—more or less consciously.

To a great extent we are thus shaped by the world around us and how we understand or misunderstand its truths. So if the self is an interface as Ong argues—at least partly it is the interface of an agent making decisions, the part that makes us the most human on our journey. Our old world may no longer form us to the same extent as the new one we inhabit, but it does hold some-thing of an entrance key to our self-understanding. And I must add the trau-matic memories I've recounted above are hardly its whole story. In their day to day lives, most of the members of the Polish community carried out their duties toward their families and Canadian society quite well. And the tasks they carried out partly reflected the variety of backgrounds they came from back in Poland, from university educated to a variety of labor or farming backgrounds, or training they received during the war effort, which they then adjusted to avail-able employment. In a harmonious society different classes are necessary since they are often the domain of specific virtues that complement each other. In a miniature fashion that is what the Polish community represented within their new homeland. In essence they were united by culture and historical memory,

and that is what they provided younger members such as myself who were open to it, and among that enriched culture was also the second language, which has great potential to broaden one's views on a number of matters.

One scholar within the community made a particularly strong impression on me. Stanisław Chojnacki was the chief librarian at the Jesuit College at the local university. He had started his studies at a Polish university when the war broke out and completed them in Canada where he ended up. And yet when I met him—he was responsible for the exchange program between his Jesuit college and the Catholic University in Lublin that I participated in—he claimed Canada was actually where he ended up after his second exile. Shortly after he had completed a higher degree in Canada the opportunity opened up for him to work as a librarian in Ethiopia. While there he gained the trust of Emperor Haile Selassie, especially in the matter of saving the heritage of the country at a time when well off tourists were buying out much of the art. Mr Chojnacki became an internationally acclaimed expert in Ethiopian Christian art while collecting it for the country's major museum. During the communist coup in Ethiopia in 1974 that overthrew the emperor Mr Chojnacki met a young friend who had participated in carrying it out. This meeting must have taken place already after the emperor was overthrown but I did not catch that in our talk. The young man informed him whom they would subsequently deal with. Listening to him, Mr Chojnacki was intelligent enough to realize his own position in the country was threatened, and when he pointed this out to his interlocutor the latter agreed. But he warned his young friend that revolutions tend to eat their own children, and of course he escaped and survived—he lived to tell his story—but he eventually learned the young man was indeed killed.

A major problem with revolutions—not only communist ones—is the ethos of the ends justifying the means. This was one of the differences that characterized the Solidarity movement in Poland. Called a self-limiting revolution, among other reasons because of how the freedom that Poles yearned for was linked with acting responsibly. This, among other issues, was praised by Rev Józef Tischner, the unofficial preacher of the movement. In one of his sermons during the anniversary of the seminal Third of May Constitution, the acme of a reform movement in the country at the end of the eighteenth century,[7] he linked the current movement with the highlights of the nation's history. He pointed out in hard times such as those in the past and in the present, the courage to think is a key: "Polish thinking blended criticism with building; it awakened doubts, but only to rebuild certainty. This thinking was able to inflict pain, even great pain, but did so not to sow despair but to heal. At the core of this thinking was a sacred

word—Truth." Rev Tischner stressed that in prayer we meet not only God but also another person:

> We meet here today in common prayer for the responsibility for the sacred value of Truth and for work full of sense. Responsibility can be only where fidelity is. We are faithful to ourselves. We do not want to lie to ourselves. We do not want to be lied to. In our land we want to do work that joins.[8]

This was truth and love! Father Maciej Zięba has noted that the Solidarity movement generated enormous energy in Poles, with great emphasis placed on the participation of every possible person: "Through supporting a variety of grass-root, spontaneous initiatives that arose within the perspective of the values of solidarity and the common good, Solidarity successfully extricated its members from the passivity and apathy in which they were immersed through the authoritarian regime hoisted upon them."[9] And John Paul II played a key role in inspiring the movement supported it internationally, seeing within it a confirmation of Catholic social teaching to which he was able to confer a universal message. The pope had a significant impact on what came to be known as the Third Wave of Democratization which occurred in the closing decades of the twentieth century, the author points out, citing Samuel Huntington, who came up with the phrase.

But the pope and the Catholic church also gave the movement a different form of support. Something that remained for a time in Polish society once the oppression was removed. Both community and the individual need to pause, to listen as it were. Self-knowledge also comes through contemplation. From this human end prayer is a form of contemplation. The importance of prayer for John Paul had often been noted, which he would promote regardless of the circumstances. He was not afraid to break media protocol to demonstrate the importance of prayer and contemplation. For instance during his visit to historic Wawel Castle in Krakow during his pilgrimage to his homeland in 2002 he likely spent a much longer period in silence in the chapel with television cameras from around the globe focused on him than the media has ever been wont to exhibit. Worth noting, in religion, Byung-Chuk Han observes, "The divine commands silence," and silence gives rise to a special receptivity, "a deep contemplative attentiveness."[10] The words of John Paul have caught the attention of many, but his silence was likewise evocative. And nowhere was this more the case than in his last "sermon," as it has been called, where he did not hide the fact that he was dying and was no longer capable of speaking. In the age of production, notes Han, death is effectively banished. Here again John Paul broke a contemporary taboo. Quite pertinent is the fact that in the first wave of the Covid-19 pandemic

in which Italy was particularly hard hit a number of Italians claimed the memory of the pope's "sermon" helped them face their own death.

When I arrived in Poland in 1983 and stayed on the Solidarity movement had already been crushed, but it was a pyrrhic victory for the regime and in less than a decade in the seminal year of 1989 communism came to an end. The movement was one of the great non-violent revolutions and movements in the century that played its part in bringing one the most violent regimes to an end, i.e. the Soviet Union. What served the national community also served humanity. But humanity has a short memory. In a column for the *Teologia Polityczna* website in January 2021 Ewa Thompson noted that while the uprising in Paris in 1968 with its strongly leftist bent and cry for sexual liberation was commemorated internationally in mainstream press, for instance in the *New York Times* in 2018, the Solidarity movement's fortieth anniversary in 2020 was largely ignored, despite being a far more constructive event.[11] She speculates the fact that the movement was in support of a national community, a polity which is no longer valued by the meritocracy, and also had a strong religious bent were factors that turned off the current mainstream elites.

I mentioned Poland as the country of my rebirth. Our search for truth is shaped by where we have to some extent chosen to be and just so happen to be. So what can be said about this place that shapes me and many others in both manners? For instance, how have Poles taken advantage of their regained sovereignty? Part of the answer was given in the previous chapter in terms of how they have or have not worked toward the common good in the face of new challenges. Looking at the broader picture, one can on the whole agree with the following assessment of how the nation is situated: "Although the Poles live in Europe, in some ways their experiences have been closer to those outside that fortunate continent. Whether we look at economic prosperity, cultural development, or political liberty, the people of northeastern Europe fall below the ranks of the privileged, but well above the global norm."[12] This is to some extent a picture of the uneven spread of power and wealth within the world, but likewise concerns the philosophical question of the complicated use of positive freedom—in Isaiah Berlin's sense—which reflects on both the problems related to building the common good as well as the resources for individual and cultural development in given national communities. Like so many others the Poles frequently compare themselves to their more fortunate and wealthier neighbors not realizing how fortunate they themselves are at this point in global terms. But wealth and the standard of living are hardly the most important issues.

Even among the direct neighbors of Poland one has only to look at Ukraine, which during negotiations upon gaining independence gave up its share of the

Soviet nuclear arms stored there in order to gain a guarantee that the Crimea would remain theirs. The truth, as is well known, was the eventual reneging of the agreement by the power that counted when Putin overran the peninsula in 2014, what's more claiming ominously that Ukraine is not a real country. This partial occupation has certainly not helped the country deal with serious internal problems that drag it down as well—although unsurprisingly they have a much stronger army than in the past, among other improvements. Unsurprisingly many Ukrainians look for opportunities to move to Poland, such as gaining work visas, and they are happy here and well accepted. Other aspects of the whole situation make for a complicated geopolitical situation for the country and, in turn, the region. Moreover, when Russia deals so aggressively with your immediate neighbor and makes little secret of its revanchist intentions unsurprisingly that keeps many within Poland on edge. The rather blasé attitude of the EU to this threat from Russia also does not help Poles feel secure—this at a time when the American protective shield grows ever weaker and ambivalent.

On the other hand, Poland's neighbor from the west is the most powerful country in the EU. Moreover, the country still seems to have difficulty with its own past, as witnessed in Angela Merkel's rather absurd statement on the eve of the fiftieth anniversary of D-Day in 2019, where she disingenuously claimed: "this unique military operation brought [Germans] liberation from the Nazis."[13] These types of statements rightfully evoke a certain amount of bitterness among some Poles. Not to mention the legitimate geopolitical concerns that the Nord Stream pipeline agreement the Germans have signed with the Russians and its steady construction raise. Almost immediately Radosław Sikorski the foreign minister of Poland at the time the agreement was reached vividly likened the deal to the Nazi-Soviet Pact of 1939.[14] And the development of the pipeline likewise negatively affects the Ukrainians and their position with regards to Russia. Thus beneath the much vaunted "European values" of which solidarity is crucial power politics is doing very well in the EU, especially for nations that are major players. Nevertheless, despite all these genuine problems as well as others some sort of modus vivendi with Germany is the only realistic way forward for the Polish national community at this time.

The above hardly closes the question of Poland and its neighbors, including its position in East Central Europe, the Three Seas initiative, and so on. But they are a context for what I wish to examine briefly now, which is what can be considered the essence of its self-awareness and how that affects the reality that surrounds it. One French intellectual who spent time in Eastern Europe in the mid-1990s captured a great difference between east and west at that time. Chantal Delsol— also a signatory of *The Paris Statement*—saw Eastern Europeans as people who

"increasingly considered us as creatures from a different planet, even while at a different level they dreamed of being like us. I later became convinced that it was in these eastern European societies that I should seek answers to our questions… the divergences between us led me to the belief that the last fifty years of good fortune had entirely erased our sense of the tragic dimension of life."[15]

At that time a sense of the tragic dimension of life was still very much alive in Poland, and is still partly felt in its current society. But as crucial as it is in understanding the world it did not fully help in adapting to a new communal life and Delsol was correct in sensing some complexes in relation to the other Europe, which has even evolved to a form of national self-hatred among some of the meritocracy—among them an influential group provides a distorted picture of the country abroad.[16] Nevertheless, some of the best Polish thinkers have profoundly reflected upon the tragic sense of life. And the tragic sense of life, it hardly needs adding, is an extension of the constrained view.

Speaking of France, in the art film trilogy *Three Colors: Blue, White, Red* by Krzysztof Kieślowski, one of the installments, *White* from 1994, takes place in that country. It relates how a Pole had lived with a young French woman and things were fine, but once they were officially married everything went sour and he had to return to Poland. And so, much like Poland having garnered some sympathy during its struggle with the communist regime, things would change once that was over. At a symbolic level the film might thus be considered prophetic with regards to the relationship between Poland and the EU. The bank clerk who sadistically cut the Pole's credit card in half before he leaves France even looked like Macron. Poles might rightly cringe at some of the criticisms that have been leveled at them, especially once they passed the stage of strictly imitative politics that was characteristic of the country's beginnings after regaining sovereignty.[17] I myself am convinced these criticisms are exaggerated, but it is true each stage had its problems. Polish political thinkers have argued that one of the difficulties experienced by Poland after the end of communism has been developing a modern state. In part this stemmed from the fact that unlike the Baltic states that—having emerged from full absorption in the Soviet state—basically had to start from the bottom up, Poland did inherit its own state. But this initial advantage was deceptive since that state was largely inadequate for the task ahead, which was not immediately apparent in some areas.[18] Some politicians like, for instance, prime minister Jan Olszewski in the early 1990s, reportedly had little concern for the apparatus of the state. When Jan Rokita took over a ministry from his predecessor of that government he was flabbergasted by the chaos that he inherited.[19]

There is also the problem of democracy, whether we speak of Poland or the EU. I am not competent to evaluate Polish problems after 1989 and accusations of it sliding into a soft authoritarianism, but it should be recalled that even if this were true to any greater extent, in his essay "Democracy as a Universal Value" Amartya Sen provocatively claims: "A country does not have to be deemed fit *for* democracy; rather, it has to become fit *through* democracy."[20] He gives the example of his own India, where there were obvious problems in that regard once the country stopped being a colony, but after half a century these were largely overcome. The problems in Poland were also related to a difficult transition. For one thing, although the totalitarian state maintained a democratic façade, it was a farce with, among other things, no civil society that largely had to be built from scratch. Not to mention communist states are extremely corrupt, which also had its after effects in business during the early transition and had to be somehow dealt with by building channels of transparency—one thing entering the EU has certainly helped. Moreover, the break with communism, which from the positive perspective was rather non-violent, from the negative perspective was unfortunately hardly a clean break, and this led to a messy state of affairs and tensions to say the least with consequences to this day. Furthermore, worth considering is the opinion of the authors of *The Paris Statement* on the populist movements apparently stalking Europe, showing that they are a response to real slights against their electorates:

> We have our reservations. Europe needs to draw upon the deep wisdom of her traditions rather than relying on simplistic slogans and divisive emotional appeals. Still, we acknowledge that much in this new political phenomenon can represent a healthy rebellion against the tyranny of the false Europe, which labels as "anti-democratic" any threat to its monopoly on moral legitimacy. (#34)

And slights there have been, with Poland treated from a dubious woke moral high ground by the EU powerbrokers—largely unelected—who are curried to by a Polish—usually urban—meritocracy that has been developing for some time. Likely educated younger Poles will trend even more strongly in that direction, and Poland will at the very least lose its "tragic sense" without much that is positive in return.

Truth with meaning involves responding to injustices. At one level this requires rationality which needs detachment, but at another level the pursuit of truth itself requires engagement. I shall continue my juggling act in this vein looking at some broader contexts of the above issues. For instance, currently even experienced democracies have periods in which they backslide. Some may point out that Sen's India is again experiencing problems in respect to democracy

under the rule of Modi. Many point to Poland, but here we can go over the country's head, so to speak. A number of political thinkers have noted a disturbing phenomenon in Western institutions. Niall Ferguson, for instance, finds the West imitating totalitarian China at a number of levels:

> There is a kind of low-level totalitarianism detectable in many institutions today—from elite universities to newspapers, publishers and technology companies—which reveals that practices such as informing, denunciation and defamation can all flourish even in the absence of a one-party dictatorship. And it turns out you do not need a Communist party in charge to have censorship of the internet: just leave it to the big tech companies, which now have the power to cancel the President of the United States if they so choose.[21]

But considering the problems of democracy in the EU and beyond I wish to look briefly at one specific issue—diminishing religious freedom: a major human right!

Obviously this problem is not as serious as the persecution of Christians in many parts of the world. Nevertheless, in 2018 the Vatican's Secretary for Relations with States expressed concern over "the growing prevalence of… 'a reductionist approach' to—or understanding of—freedom of religion or belief." Such an approach, he continues, "seeks to reduce religions 'to the quiet obscurity of the individual's conscience or [to private practice], revealing not only a failure to appreciate the true sense of freedom of religion or belief, but also the legitimate role of religion in the public square." Failing to understand this, "feeds into sentiments of intolerance and discrimination against Christians, what might well be termed 'the last acceptable prejudice' in many societies."[22]

There have been serious complaints regarding this problem in the United States.[23] This prejudice is certainly the case in Canada at present. In 2018 the Canadian department of Employment and Social Development introduced a measure by which it would not support any agencies that do not accept a new governmental requirement: that recipients of funds for programs must "attest" that respecting human rights means respecting "reproductive rights," which include "the right to access safe and legal abortions." A broad coalition of religious leaders protested the coercion of consciences the measure entailed for their organizations.[24] I do not know if their efforts had any effect. Their struggle likely continued for however long. More seriously assaults on religious freedom are carried out against Catholic and other religious professionals after the legalization of euthanasia in the country, especially in Ontario where regulatory boards are not granting freedom of conscience that does not allow the taking of an innocent life for these sensitive professionals. These legal issues are also part of the

moral confusion Robert George spoke of in the United States, as he states: "To stand up for the sanctity of life in all stages and conditions, beginning with the defense of the precious and vulnerable child in the womb, is to risk being labeled a 'misogynist.' To speak out for religious freedom and the rights of the conscience is to invite being smeared as a 'bigot.'"[25] Similar problems and measures are in force or arising in a number of European states, the—highly underfunded— Vienna-based Observatory on Intolerance and Discrimination Against Christians in Europe is quite busy filing reports on spontaneous instances of religious intolerance. Discrimination is especially strong in the case of those who are pro-life, increasingly so in Poland as well. For instance, in 2019 free thinker Leszek Jażdżewski was invited to give a speech at the University of Warsaw in which he voiced a screed against religion and the Catholic church, while in contrast that same year religious students at several universities in Poland had invited an American prolife activist to speak but left-wing student groups protested and the talks were limited or cancelled at some of the venues. This was a sign of things to come. As political thinker Jan Rokita put it concerning the EU, "It is a disturbing characteristic and more frequent phenomenon: if religious people today become involved in political activity, then they invariably confront the logic of the cultural war within European institutions."[26]

Times may be changing and pro-abortion activists are becoming quite strident in the Poland, and even mainstream among the liberal and leftist elite, but the country nevertheless boasts among the most prolife societies in Europe. Even a poll taken after strong pro-abortion demonstrations in 2020 showed that only 22 percent of Poles believed abortion on demand should be legal in the first twelve weeks. And it is not only religious Poles who are prolife. An example of a secular Pole who opposes abortion on scientific grounds is the fantasy writer Jacek Piekara. He tweeted: "As an agnostic, I'm mad at rubbish that people who oppose abortion are religious fanatics, a kind of Catholic Taliban. In reality, opposition to abortion is merely witness to respect for human life in its most vulnerable and delicate form."[27] One wonders from this if to some degree this high value placed on life in its most vulnerable phases is not somehow connected to the memory of the occupation in Poland when human life—especially of the inhabitants of Poland—was deemed of no value by the forces occupying the country.

One of the outstanding members of the prolife movement in Poland, Wanda Poltawska, can be considered to combine both the scientific—from the perspective of medical science—and religious sides of the issue. As a young woman during the Second World War she had been imprisoned at Ravensbrück concentration camp for passing messages to the Polish resistance against the Nazis. There, German doctors who wanted to see what would happen to bacteria

under certain conditions injected bacteria into her marrow, among other women. Since Poles were considered slaves by the aggressors they were ideal for such experiments. The needles the doctors used caused open wounds on their human victims and then they injected them with pus, causing the women agonies of fever and pain, often ending in a horrible death. Wanda had also "died" after four years at Ravensbrück. Or so the woman doctor thought when she looked at her motionless body. "Number 7709," she said. "Throw her on the pile." If a friend had not noticed her finger twitching on that pile that would have been the end of her.[28]

While she was in the camp she vowed to God that if she survived, she would become a doctor: someone who healed people. Memories from the camp haunted her for years, but she earned her doctorate in psychiatry, and ministered especially to survivors of the camps, as well as to children who had been abused. In other words, she took her Hippocratic oath as a doctor very seriously, and became strongly prolife. Quite evidently, from early on after her recovery she practiced the moral principle that one must fight evil with good.

Shortly after she started her medical studies in Kraków Wanda and her husband became close friends with a young bishop in the city, named Karol Wojtyła. No doubt radical feminists cringed at this, but John Paul II has been called a pro-woman's pope by the prominent Christian feminist Elizabeth Fox-Genovese on account of his recognition of the special "genius" of women.[29] It is in no small measure thanks to his relations with women like Wanda Poltawska before he became pope that this intuition came about.

Significantly, the Nazis at Ravensbrück and other camps considered themselves scientists. Ideologies that led to deaths on an unprecedented scale in the previous century generally felt they had science on their side: fascism, considered an irrational form of nationalism, which was certainly a crucial aspect, nevertheless it had its roots in social Darwinism that applied biological concepts of natural selection and survival of the fittest to sociology, economics, and politics. Among their medical experiments at concentration camps the Nazis practiced eugenics. The Germans, after all, were the master race, and the Slavs, were beneath them, while the Jews… need I say more! Communism, thanks to Marxism developed what was termed "scientific socialism." Human sacrifices were inconsequential on the road to a glorious future. And sacrifices there were! The authors of *The Black Book of Communism* of 1997, with the Polish historian Andrzej Paczkowski among its contributors, estimated the numbers of victims to be around ninety four million. Of course it will only be possible to get a more accurate number once Russia and China allow access to their archives, which is highly improbable in the first case and virtually impossible in the second. So

when science is compared to religion as a more credible road to truth such facts must be considered. Who's to say some current scientific ideas are not or perhaps will be used for similar purposes, perhaps more subtly, perhaps not. It is best when both religion and science are in the hands of the Wanda Poltawskas of the world.

In suggesting a relationship between science and religion, I say this working at a university at a time when even scholars are often enough unaware of the connection, which to no small extent historically involves their own institution. Although the university I work at is a post-war institution and thus fairly recent by European standards—its patron being the first woman to gain a Nobel prize in science, Maria Skłodowska-Curie—just about a hundred miles away in Krakow is a university that dates back to the fifteenth century, with Nicholas Copernicus as one of its earliest alumni. Scientific exploration at the time was grounded in scholasticism, based on faith seeking understanding. It was understanding inspired by wonder and reason. Worth recalling is the fact that although science as a separate discipline arose a few centuries later, it finally became evident to some of the great thinkers of the last century that the seed for its flourishing was planted in the Middle Ages with their universities and scholastics. Alfred Whitehead, co-author with Bertrand Russell of *Principia Mathematica*, put it thus:

> When we compare [the] tone of thought in Europe with the attitude of other civilizations when left to themselves, there seems but one source of its origin. It must come from the medieval insistence on the rationality of God, conceived as with the personal energy of Jehovah and with the rationality of a Greek philosopher. Every detail was supervised and ordered: the search into nature could only result from the vindication of the faith in rationality.[30]

Significantly, one of the great works of Polish art that illustrate this truth is Jan Matejko's nineteenth century painting *Astronomer Copernicus, or Conversations with God*, in which the eponymous scientist looks up into the night sky with inspiration, as if about to experience a religious epiphany.[31]

Of course there was an irrational vein of Christianity, especially after the Renaissance—a connection not often made. It's enough to remember Luther's claim that reason is a whore.[32] But there is a more serious issue connected with the rise of science. With science power came to Europe. And as many know power corrupts. Fascism and communism, with its self-proclaimed "scientific socialism," are only a couple of examples, which I raised since they are not always associated with science; also less directly obvious are the abuses of colonialism by technologically advanced European powers. Power abhors a vacuum. Upon deeper reflection of what we know of human nature it is simply too difficult to

imagine for Europeans or anyone else in their place not to have used the power they possessed to their advantage at some point, which is not to say that it should not be strongly criticized. And we have not even begun to discuss technology at any length, the handmaid of science, and modern warfare with its victims. All this should be borne in mind when considering science as one of the roads to truth. This might be true, but the above qualifications among others must be taken into account.

Two fundamental interrelated matters should be borne in mind when looking more attentively at the harm that people have done with the aid of science. For one thing, the origins of science are not quite as innocent as we generally think. A common opinion is science was an outgrowth of the spirit of rationalism that religion hampered. We have dealt with the falsity of religion as such hampering the origins of science, what about its roots in rationalism? If we set aside religion and its more rationalist bent as one of the answers another key aspect comes to light that provides a counterargument to any early connection of "pure" rationalism with science. In his magisterial history of ideas *The Kingdom of Man*—actually the last part of a trilogy—historian of ideas Remi Braque argues the origins of science were rather connected to the primeval human desire to dominate nature. "The modern enterprise of a conquest of nature has the same project as magic," he claims, adding: "As for history, it reconnects with late antiquity by bypassing the Christian Middle Ages. The latter was little tempted by magic, which the Bible forbids." It is highly significant that the struggle the Church had with the alchemists in the Middle Ages had its consequences in modernity: "Before the control of nature became actual, even before its conditions were assembled, a human type appeared. This is the figure of the magician, which allowed a psychological reorientation of the will towards action."[33] The literary figure who embodied this man was Faustus. Interestingly, the contemporary work that stresses the dangers of this manner of thought is J.R.R. Tolkien's *The Lord of the Rings*. As a scholar he was quite familiar with medieval thought. So perhaps it is unsurprising in a letter to his publisher he made a connection parallel to that of Brague's concerning the relationship between magic and science—or "The Machine," as he puts it—in his literary mythology.[34] In his literary opus, although those who resist temptation and struggle with it come to the fore, Tolkien explores the evil side of Faustian pride with the eponymous dark Lord of the Rings. Brague argues that magic was primarily abandoned because it turned out to be ineffective, not because it was considered irrational.

At a somewhat more quotidian level the problem is, as C. John Sommerville so aptly put it in his *The Decline of the Secular University* of 2006, we generally forget that despite the authority we tend to proffer it at present, "Science

is a human practice, embodying human intellectual categories, serving human purposes, having no purposes of its own."[35] And as I have noted, some of those purposes have been quite tragic for humanity. Naturally this is not to negate the fact that science has been used for good purposes. And that it can also be allied to rationality. But the human side of science often means that those who serve higher purposes with the aid of science do so because they have found deeper meaning from some other source—often enough religion. The weighty problem we have to deal with and that I can only indicate is how this relates to the truth of what it means to be human, both in the positive and negative sense.

If in the previous chapter we looked at how secularization can have a detrimental effect on community and the common good, Sommerville sees a problem in how secularization has affected that arena for the development of the intellectual virtues as well as the intellectual search for truth, the university. Among the crucial areas where the university has failed on account of this development—he primarily speaks of the American university—is in the question of what it means to be human. In his view the university should be aware that the most important matters in life include trust, hope, purpose, and wisdom, that fosters a more holistic view of the world. Yet, as Sommerville complains, "We have dodged this issue by saying that true, good, just, are all political, meaning that they can't be discussed but only voted on." He notes that among the consequences of this has been the rise of intellectual fashion as opposed to a wide range of approaches on various topics based on open debate as to the strengths and weaknesses of each of them.

What is more obvious now a number of these intellectual fashions become politicized. Take the problem of diversity. Diversity in itself is of great interest except when it is defined in a way that limits open discussion. Already in 1999 philosopher John Searle complained that diversity promoted a kind of conformity of progressive values "and a consensus of a victimhood interpretation of history in general, and of American history in particular." He wryly noted that the only place in academia he came across real diversity was years earlier in his old college at Oxford where every conceivable political stance was represented as were a great variety of ethical, social and sexual lifestyles, not to mention other preferences. He claimed: "There was complete tolerance based on a mixture of snobbery, security, smugness, and, above all, indifference."[36] Searle complained the liberal arts tradition and its strengths were being squandered by the politicization of the curriculum, which betrayed the vocation of the university based on its "universal" mission. To the extent that I have been able to follow this debate in the United States, the process has obviously advanced considerably since he wrote this.

Polish poet laureate Czesław Miłosz happened to be teaching at the University of California when one of the European scholars who gave an impetus to the politicization of discourse in American universities turned up. In the second half of the 1960s Herbert Marcuse, philosopher, sociologist, and political theorist, associated with the Frankfurt School of critical theory, was a colleague of Miłosz's in the San Francisco campus of the university. Although the German scholar was critical of Soviet communism, the Polish poet observed a more disturbing side to Marcuse, whom he noted did not accept the fallen nature of man, in other words our tragic dimension: "As with many Marxists, hatred for man as he is in the name of man as he ought to be determines the emotional tone of [his] writings." Miłosz is not blind to the strengths in the philosopher's thinking, but he poignantly adds, "To consider the citizens of any country, as Marcuse does, blameless idiots but idiots nonetheless, is to condemn oneself to intellectual arrogance."[37] Having written this at the end of the 1960s the observation can be considered a sign of things to come.

The broader problem, as Sommerville convincingly frames it, is that much of what makes us fully human cannot be accounted for in secular discourse that now dominates the academy. Much of the damage goes back to Darwin, after which it was no longer possible to say as Jefferson had, that we are all created equal, since how could we say that we have "*evolved* equally." The sciences, for instance, have a mixed sense of the universe. After the Big Bang Theory cosmologists intuited the need of some sort of creation talk but were at a loss how to do so within their discipline. On their part philosophers, among other means, attempted to accommodate the sense of the human after the loss of religious notions by maintaining natural law doctrine, while later on existentialism provided some help, but neither were ever capable of capturing the public mind. Among the consequences of the ensuing secularization of discourse in the American university is that all the most profound terms of human affairs lose their coherence in the naturalistic discourse that dominates in the academy. The broader consequences of this? "If universities rule out all such discussions as soon as they recognize them as religious," then Sommerville warns, "serious discussions will migrate to some other venue."[38]

Things have rather got worse than better since he made his observations. And since Europe is generally more secular that the United States, the above problems can hardly be absent from within its bounds. It might be added both in the United States and in Poland some think tanks and foundations are working at filling in the vacuum, but that is only a partial solution to the problem. The question remains how can we even approach a better understanding of the truth

of our human essence without the broadest possible discussion, which, among other things, a university should provide.

One of the human realities western universities have difficulty speaking about at present is evil. In search of a treatment acceptable for academic discourse on this metaphysical aspect of existence Sommerville turns to Leszek Kołakowski, whom he notes experienced communism, which gives him greater experience with the reality of evil. The Polish philosopher also finally came to the realization that the problem cannot be treated fully without turning to theology: "With the disappearance of the sacred, which imposed limits to the perfection that could be attained by the profane," Kołakowski writes, "arises one of the most dangerous illusions of our civilization—the illusion that there are no limits to the changes that human life can undergo."[39] Here the Polish philosopher not only comes to the conclusion of the truth of the constrained view of human nature, he points out the danger of the unconstrained view. Kołakowski, however, goes further, forcefully indicating the relationship between evil and ideology. "The Devil incarnated himself in history," he famously claimed, adding: "The devil… invented ideological states, that is to say, states whose legitimacy is grounded in the fact that their owners are owners of truth. If you oppose such a state or its system, you are an enemy of truth."[40]

If it is somewhat easier for some to accept evil as somewhere out there—in a totalitarian regime, for instance, often we are unaware of its proximity closer to home. In one of his short pieces for *The New York Review of Books* Czesław Miłosz pointed out that there is more to the common disbelief in an afterlife than just a "rational" view of existence: there is also a wish that there are no consequences to what we do. This is obviously the poet's gloss on Ivan Karamazov's statement in *The Brothers Karamazov* that if there is no God everything is allowed. But Miłosz saw that it can be applied to trends within the secular segment of American society, which has its nihilistic side that is becoming more and more evident. And this currently visibly affects more than just American society.

With a few notable exceptions where Newman's idea of a university in the spirit of a search for truth still holds,[41] the modern university in Poland rather emerged from the Humboldtian tradition of the research university which was appropriated under communism—without much success in the long run—to serve Marxist ideology, but returned to these roots after 1989. Nevertheless, a tendency of heading toward a "knowledge factory" approach has taken hold, not to mention intellectual fashion is also a problem within that research and teaching. And the roots of the latter are likely to no small extent to be found in influence of the politicized European universities, with which the Polish universities mow have deeper ties. As the authors of *The Paris Statement* put it:

Europe's intellectual classes are, alas, among the chief ideological partisans of the conceits of the false Europe. Without doubt, our universities are one of the glories of European civilization. But where once they sought to submit to each new generation the wisdom of the past ages, today most within the universities equate critical thinking with a simpleminded repudiation of the past. (#20)

Perhaps paradoxically, such a repudiation of the past, an element of what might be called chronocentrism[42]—mistakenly believing our time is the acme of what it is to be human, or that at minimum we now have the potential to practically or perhaps the necessity to start over from scratch—also has a long history, or at least quite early precedents. The Marcionite heresy was along such lines. In the second century of the Common Era Marcion believed the Hebrew scriptures should not be accepted in the New Testament because they were essentially outdated. In the unconstrained view that Gierycz argues dominates thinking at the EU level everything human is fluid, so in a related manner the past hardly counts, if it is not to be rejected outright.

There's an often quoted passage from C. S. Lewis's *Mere Christianity*: "Progress means getting nearer to the place you want to be. And if you have taken a wrong turning, then to go forward does not get you any nearer. If you are on the wrong road, progress means doing an about-turn and walking back to the right road; and in that case the man who turns back soonest is the most progressive man."[43] This is worth recalling at a time when the progressive has become a religion in various sectors of society including academia in many countries. Its religious nature is demonstrated through cancel culture where certain ideas are anathema. Here is where the liberal arts tradition with its emphasis on dialogue and debate is so necessary to uphold.

Among the positive developments for religion in the academy according to Sommerville is the rediscovery of narrative. Long relegated to simply describing different aspects of reality, narrative has once again become a method of inquiry. This was perhaps more true when he wrote his book but it is worth looking at what value narrative holds for truth seekers. But narrative as a tool for seeking truth needs some qualification, since it can and has been abused. One of the primary reasons why narrative does penetrate reality from this perspective, Sommerville argues, is the role it has played in the West in sacred texts. Crucially, the narrative framework that this entailed "is not propositional, declarative, epigrammatic, or prophetic so much as historical. And it is the history of humans."[44] Narrative in this sense, we might add, is closely connected to our relation with time. Without narrative and a sense of history we are trapped in time, which is basically results in our being chronocentric, and I would add with all the consequences of a limited consciousness of what it means to be human in time.

Narratives of history are often embedded in the historical memory of national communities. This makes the history their own and not that of some abstract humanity's. Of course ultimately there is indeed one history of humanity, but for the foreseeable future that is beyond the grasp of most people at any more personally meaningful level: globalization does not actually help, focusing as it by and large seems to on the here and now. The national communities, on the other hand, can be considered guardians of their share of that history, and thus aid in keeping it alive for its members and everyone else who cares to encounter it. In Europe there is a good deal of history that Europeans would rather forget. From the perspective of modern France, historian Pierre Nora has talked about history in terms of foreignness for his compatriots. With an "accelerated" present and a past that included episodes like the Vichy collaboration with the Nazi Germany this might be understandable. One could argue that in Poland with its loss of sovereignty for so many decades, however, historical memory plays a stronger role in the self-consciousness and understanding of the national community, since it has been a long-standing element in the struggle for national identity.

However, at a deeper level historical memory cannot be so easily gainsaid for any contemporary society. From a philosophical perspective, one pertinent school of thought connects the relationship of historical narrative and history to an essential phenomenological aspect of being human, and being human in community. Unlike those theorists who feel there is no continuity between historical narrative, which derives its strength from coherence, and life, which allegedly lacks it, the philosopher of history David Carr insists that there is a correspondence between historical narrative and life, both at the individual and social level: "For the *we*, no less than for the *I*, reflectively structuring time in narrative form is just *our* way of living in time."[45] One can add that from this perspective history is the life story of community and those who are enriched by it.

These memories are kept alive in various manners. For instance, institutionally through different museums which attempt to keep up with the times or circumstances—online exhibits during the pandemic, and so on. Filmmaker Jan Komasa was inspired to make his film on the Warsaw Uprising after visiting the newly opened museum dedicated to the event. *Warsaw 44* (2014) is hardly a great work of art, but it did bring the event closer to one generation of young Poles. The historical memory in these filmic narratives is most effective when joined with a vigorous moral imagination; the western tradition going back to St. Augustine includes critical self-examination—the most difficult type of examination to conduct with full honesty.

A nation needs heroes—that is, exemplars of virtue—and during its greatest trial during the Second World War these were not in short supply in Poland. To

rehearse some of the general facts, the Poles together with most of their ethnic minorities—I mentioned the Tatars in the last chapter, but they were not alone—were the first to fully stand up to the German onslaught. In Spielberg's *Schindler's List* the introductory intertitle states that it was the Germans who defeated the Poles—the filmmaker did not bother with the politically correct version that it was a Nazi occupation. The film is set in Krakow—or rather *Krakau* under the German occupation—and focuses on the Holocaust. And although a Nazi psychopath camp commander is the in film's criminal center stage, Spielberg also shows some of "Hitler's willing executioners," to use Daniel Goldhagen's expression for the common German soldiers in action.

Part of the non-military heroism of Poles was demonstrated toward their Jewish brethren, as is depicted in Roman Polański's historical biopic *The Pianist*. I use the term brethren from the perspective of John Paul's referring to Jews as older brothers in faith, although a large segment of Polish society before the war did not think that way—anti-Semitism was certainly a genuine problem. It is not made clear in the film, but the friends who provided shelter for the protagonist, Wladyslaw Szpilman, when he escaped the Ghetto in Warsaw were actually risking their lives in doing so, since the penalty for ethnic Poles helping Jews in occupied Poland was death—which was not the case in most countries occupied by the Germans. What Polanski also dramatically depicts was the broader context of life in the occupied country—the Poles themselves were involved in a heroic and hopeless struggle against the occupying force. In essence, the country was the site of the largest organized underground resistance against the Germans. What the viewer sees is the end result of one of the largest uprisings against that occupying force in Europe. Szpilman loses his first hiding place when that part of the city is effectively destroyed by the Germans after the Warsaw Uprising is crushed toward the end of the war. The Jewish survivor himself is shocked by what he sees in the city once he abandons his hideout in search of food. The film basically implies at this juncture what historian Michael Steinlauf notes: "Nowhere else in Europe did the murder of Jews unfold amid such slaughter of the coterritorial people."[46]

Yet five years of a heinous occupation certainly left their mark on the psyche and morality of Poles. It is simply not humanly possible even for the most courageous people—and Poles were certainly up there in this category—not to have a significant portion of the population demoralized under such circumstances, even if that portion was a minority of the whole, not to mention many who were somewhere in between. Thus it could hardly be the case that it was just a handful of individuals who were demoralized as some Poles try to convince themselves, for instance in cases of betraying Jews to Germans. The problem

here is the human tendency to take away virtually all blemishes from heroes and, conversely, all humanity from villains. From this latter perspective, the difficulty with painting the Germans as monsters is it augments the belief that the Holocaust was a unique event in the sense that it was an aberration which would imply that could not happen again, whereas with our knowledge of the human condition it should be clear that "there but for the grace of God go I," we might best put it. Without this knowledge the repetition of the event in some unforeseeable future is all the more likely. The Germans were humans, perhaps at their worst in a number of instances, as were the Poles—human, that is—even despite the presence of numerous genuine heroes. A Polish film that bravely explores this darker nature of Poles is the internationally acclaimed *Ida* (2014), which not only shows the moral failure of a Polish peasant, but also a Jewess repatriated to communist Poland from the Soviet Union and with a history of participating in the execution of ethnic Poles from the underground that resisted the subsequent Soviet occupation.[47] Needless to say these are part of an extremely complicated history not fully dealt with to this day by Poles and barely understood outside the country.[48] And so at different extremes within the country the film was thus declared anti-Polish on the one hand and anti-Semitic by the other.

In her monumental *The Eagle Unbowed: Poland and the Poles in the Second World War* Halik Kochanski recounts at some length the entire history of the Polish experience and effort during that seminal eponymous event, that together with its aftermath essentially did not come to a conclusion until 1989. She notes that subsequently after joining the EU the attention of Poles is focused westward, rather optimistically concluding: "This return home has taken time, but now that Poland is once again free, the final chapter of the Second World War has at last been written."[49] The above films and others like them show that in terms of historical memory and dealing with it as honestly as possible the chapter is hardly closed in the country. Critical self-examination needs Augustinian moral courage, which is not to say that heroism should be forgotten. Far from it, heroes must be given their due—even though chinks in their moral armor may also be evident.[50] As one Polish pundit put it, statues are raised to heroes because they are rare. Which is true even though in that seminal period of Polish history they seem to have been more abundant than in many other places. At any rate no national community is without its darker moments that must be faced for the fullest self-understanding. A crucial matter is whether this self-examination is faced with tough love or self-hatred, which has its own aberrations.[51] Nor is the "West" to be idolized at this juncture as I believe I have made clear.

Coming back to the problem of a national community being a guardian of its own share of world history, obviously it is rewarded in this by receiving a tool to

strengthen its national identity. It also has the right to present that history to the world, though Poles likely have not done so to the extent or as effectively as their history deserves. But what about moving on and creating a considerably larger history—say, a viable European history. What I mean here is not a textbook, since many exist, but rather a narrative that effectively communicates this history to the citizens of Europe and the world. If in a national history it is so difficult to create a fully truthful account then a European project is that much more challenging, if at all possible. Frank Furedi briefly outlines the historical politics of the EU in his study *Populism and the European Culture Wars* of 2017. Even in the 1990s there was an awareness that historical memory provided a source of legitimacy for the union's existence. At the onset of the new millennium the New Narrative for Europe project was initiated that, according to one commentator, was based on the premise that a "common history is obviously the main source of collective identity for a community."[52] Ironically, the participants in the project found it so difficult to come up with compelling shared stories that the terminology was changed from "narrative" to "narratives." As noted in the previous chapter the House of European History, opened when Poland was already a member state, likewise largely failed.

   This general EU approach hints at part of the problem that Ewa Thompson captures in her report on a conference/workshop on European memory where she indicates that the postmodern constructionist approach to history prominent in both the United States and Europe early in this millennium implicitly "promotes the view that might makes right," which in terms of East Central Europe suggests "that certain groups and people produce 'occurrences' not worth remembering, occurrences that may be mentioned wholesale, but then quickly dismissed."[53] With this approach it was not worthwhile pointing out the accomplishments of areas such as East Central Europe, nor of making the effort to untangle more complicated issues. Thompson notes grave distortions of Polish history by major German historians, among others. When I visited a friend in Switzerland in 1985 she gave me a historical atlas that was originally published in West Germany. In it was a map of present day Poland which had the territories marked that were taken from Germany and given to Poland during the Potsdam Conference at the end of the war. What was missing was any indication of the territories which had been taken away from the Polish state that had belonged to it in the east before the war, and which were actually larger than those that had been given in the west. From Thompson's report it seems distorted perceptions concerning countries to the east of the powerful German state are largely still the order of the day. Not to mention if the fact that the countries of East Central Europe passed through the empire of evil, as Ronald Reagan aptly called it, and

this is simply an "occurrence," then the Western European neighbor has virtually no idea of what's important in history.

And so a seminal reason a common history is so hard to work out among Europeans as implied above is the differing sense of what is most important within it among the different national communities. Here we also return the question what Delsol called the tragic dimension of life applied to history, whether within a national community or beyond it. Obviously this could never by plumbed by a postmodernist approach that believes in the constructionist nature of the enterprise. We do find fruitful attempts to plumb the tragic sense of politics in Polish thought. In her review of the book *Thebes-Smoleńsk-Warsaw* (2020) by Polish political philosopher Dariusz Karłowicz, Ewa Thompson notes that "Karłowicz posits that *Antigone* and the related plays of Sophocles and Aeschylus anticipate the pride of Enlightenment rationalism (not to be confused with Aristotelian rationalism!) that leads to chaos and disorder and an eventual debacle. The tragedy of Thebes is a reminder that without a transcendent reference point, politics turns out to be deadly."[54] And Karłowicz brings this tragic sense of history and politics up to the present day, providing a commendable gravitas to political thinking. For a view of the European project from a similarly profound perspective, Remi Brague's *The Kingdom of Man* referred to above looks at the entire modern project in the continent in a manner that is critical of its overall support of a highly unconstrained view of humanity: the "malleability of the human species" as Locke put it. Moreover, Brague considers the consequences of the failure of the modern project, among them he notes that attempts to establish human power come with enormous burdens, among which the problem of evil is particularly acute, for "in vindicating the goodness of man as affirming the independence of man from every superior instance, modern thought made him responsible for everything, including evil."[55] One can see the problem is related to the question where does redemption come from in these circumstances. Can redemption come from man himself? Self-absolution has a false ring while self-hatred that also can be observed is no solution, often leading to further aberrations. At any rate if in *The Strange Death of Europe* Douglas Murray has with considerable accuracy observed the decline of Europe in its present form, astutely describing some of its symptoms, Brague in his brilliant history of ideas supplies much of the answer as to where the historical roots of the crisis are found.

It is relatively easy to see the question of truth and meaning arise in examining history through narrative. Whether it serves a national community or not, historical self-examination is quite obviously connected to the requirement of truth. There is also the rather scientific side of the historical enterprise that insists on as

thorough an investigation of the evidence as possible to judge where the "objective" truth might lie. Like every scholarly enterprise, this is also questioned, but is likely the closest track we have. However, remaining with the question of narrative I wish to now look more closely at whether the fictional narrative can bring us closer to truth and meaning rooted in wisdom. Here I wish to add a qualifier. It has been pointed out all truths are qualified in some manner. Harvard philosopher Hilary Putnam as well as Nobel laureate Amartya Sen and Francis Fukuyama have pointed out, as Sommerville notes, "philosophers, scientists, and economists have never been able to absolutely separate fact and value."[56]

But I do not wish to take advantage of such uncertainty of which too much is made at times to forward the highly different nature of truths found in fictional narrative. What concerns me, at least in part the problem is related to a similar question raised in the first chapter of the genuine "life in poetry" as Mary Nichols put it—or the "life in story" that I would like to explore now, and this is all the more important in that "life" is the existence that we possess together with the window through which we perceive it. Also worth considering, as Joseph Kupfer notes, "The narrative arts are not merely ancillary to understanding human nature and the many ways it can go right or wrong. Rather, stories uniquely capture formal aspects of the lives of individuals, real and imagined, needed for us to make sense of them."[57]

In philosophical terms some works of fiction can be described as thought experiments; a tool that is used, for instance, when it is not possible to subject reality to such experiments for moral reasons. In Ang Lee's *The Life of Pi* (2012) an adolescent is subjected to a solitary seven month journey mostly on the open sea in which he is extremely fortunate to survive. We might quibble about the time frame, but we could not subject any human being, let alone one as young as Pi, to such a test even to learn some philosophical truth about life. An artist has that liberty. And though the insights he—in this case—gains are not the same as from a genuine experiment, the train of thought released can be quite fecund: for the artist and the viewer. Especially if the artist brings a great deal of himself and his world into the work.

That particular movie is important for a number of reasons. Let's start from the artist's world. I mentioned the situation of Ukraine in which part of their territory continues to be occupied by the regional power that gives all of us in this part of the world geopolitical shivers. Not all that dissimilar to our Slavic neighbor's position in the world is that of Taiwan with its close proximity to the Republic of China. It may be true that there are no soldiers from their powerful neighbor on their island, but the situation is similar in that the Chinese leadership does not consider Taiwan a genuine country. And how the denizens

of Hong Kong, who were formerly free like the Taiwanese are now, are being ruthlessly treated at present must give them nightmares. Some of us can recall toward the end of the last century people from Hong Kong looking for a haven in various countries around the world before their city state returned to the Republic of China. Although the demonstrations were some time after the movie was released a significant number of citizens of Taiwan have likewise been looking for a haven wherever they could find it for some years now, and who can blame them.

So if the situation of Poland, as mentioned above, is "below the ranks of the privileged, but well above the global norm," as far as per capita income and lifestyle goes the Taiwanese are in a similar position and possibly even somewhat ahead. But their geopolitical situation places them in quite an unenviable position. It would seem to me Ang Lee seems to capture much of that anxiety in his *The Life of Pi*. But the story goes considerably further. It is also a love story, but of a different kind. One might call it a love story of life and creation despite all its threats and contingencies.

Lee is a filmmaker who often hides behind other people's stories. Many of his films are adaptations, as is *The Life of Pi*, from a novel of the same name by Canadian author Yann Martel. The introductory part is set in India, with a charming young Indian named Pi who, raised in the Hindu tradition, primarily on account of his mother, becomes enchanted with Christianity and Islam, and accepts both religions without abandoning his Hindu faith. One might add that when he ends up in Canada after his grueling adventure, he admits to teaching a course on the Cabbala at the university where he works. When his father has to sell the zoo the family runs in Pondicherry, India, the family with a number of their animals boards a ship headed toward Canada. One night a terrible storm hits the ship and it sinks, but not before Pi is literally thrown onto a lifeboat where he ends up with several of the animals. Eventually, however, he's left alone on the vast ocean with the tiger named Richard Parker. The accidental name the carnivore is labeled with does not change his nature, and the endless journey that takes up most of the film and eventually takes them to the shores of Mexico requires Pi to use all his skills he gained as a zookeeper to keep the beast at bay. And in this he demonstrates no small measure of practical wisdom.

In the film's frame story a writer from Canada visits the adult Pi in Montreal since he has learned from the latter's uncle that the survivor has a story that will make him believe in God. Although God is mentioned often enough in the film, it is not so much a film about religion and community as about the essence of life. Significantly, when the writer confronts Pi regarding what his uncle told him about his story there is a tragic look in the expression he gives in response. The

story he first relates about his survival is fantastic and full of wonders, followed by a brief, more banal version related orally in the film, yet the literal tragedy is that he survived but his family did not; its members were still in their cabins when the ship sank. It would not be too much to say that in Pi's expression above is an awareness of this: he has not forgotten his family. The father had made an intelligent comment at one point back in India when Pi already claimed to be an adherent to three different faiths. The patriarch reiterated that he himself was a rationalist with no faith, but he expected Pi to choose one faith since it appeared to him his adolescent son simply could not decide on one. And at that point of the film it seems like he is not so much searching for God as engaged in a playful syncretism. It is the events of the story that prove there is more to Pi than that—at a human and symbolic level. When he is on the raft courageously facing an exhausting quest for survival, these different faiths make him a religious and human everyman. In a sense this aspect of the protagonist and the weight of the narrative suggest that in one way or another we are all in the same boat of life.

At one level it might not be stretching it too far to see the demise of Pi's family as Lee asking the question what would happen if Taiwan lost its independence. And the struggle of Pi on the lifeboat out at sea with the tiger might be taken as an allegory of the people of Taiwan and their tenuous position in the face of their powerful and aggressive neighbor from across a relatively small body of water. Some elements of an oriental philosophy are also evoked in the film, especially during the oceanic survival journey. For instance, the ocean is life threatening but also life giving; this duality is there in a number of the elements of the journey and the story. They all form a highly yin and yang dynamic—the ancient Chinese philosophy of how things that seem to oppose each other are actually complimentary. A good portion of the life in the film that buoys its art is the life of Lee and his world that can be detected within it in a symbolic or thematic manner. These aspects that relate to Lee's culture are important since they add a degree of authenticity—in the best sense of the word—to the story. The story has a specific truth that relates to the storyteller. But we also bring something of ourselves into the film as we watch, a viewer or critic from a country that has similar anxieties to that of Taiwan may see *The Life of Pi* differently than one from a country with a more stable geopolitical situation.

The narrative of the film also plays with a realistic version of the story of survival presented orally. At the end of the film the listener who stands in for the viewer is asked to decide which version is real. But the truth is they are both the same story at a different level. At a filmic level one represents the tradition of realism, the other a sort magic realism, both being important in film art. Usually they would be in separate films but here Lee gives them new meaning by

confronting them with each other to challenge us to think. However, the fantastic version does approach a mythic dimension with a universal message, and I will attempt to tease out part of that with the help of a perceptive study.

In her study of *The Life of Pi* Marjorie Suchocki finds the question of redemption quite important. Redemption in the film, she proposes, "is not any single external thing but the capacity to see in all things the dual qualities of sustenance and danger." Lee essentially provides us a rather unusual love story; a love for life and all forms of life, even the threatening ones. A key element of romantic love is its reciprocity together with all the virtues needed to fulfill its demands. In *Pi* Lee directs our attention to a love that might not be reciprocal but is life affirming nonetheless—like the love of God which we often do not reciprocate. One of the key elements of this love, Suchocki convincingly argues, is gratitude:

> Gratitude pervades Pi's attitude throughout his struggles.... This gratitude is in itself redemptive in that it inspires both courage to endure, and a kind of freedom that goes beyond circumstances. Gratitude does not blind Pi to the dangers surrounding him; rather, gratitude gains its edge—its transcending value—precisely because it lives into the dangers toward life, even though surviving the dangers is never assured.[58]

But referring this astute perception to the most provocative question brought up in the film, is such gratitude enough to make you believe in God? *The Life of Pi* teasingly proposes the question at one level, but is actually wise enough not to insist on an answer—Pi himself tells his story but lets his listener decide. Nor was he the one who suggested this would be its effect. The most important thing is that the question is raised in the film. To reiterate our earlier observation, much of what makes us fully human cannot be accounted for in strictly secular discourse, and fortunately on occasion a great artist moves beyond its ken. And gratitude certainly is one such virtue that requires the broadest possible context to understand with greater probity. We, in turn, are grateful for the truth of stories that direct us toward any significant insight on the meaning of life and existence. Not to mention a deeper sense of the virtues. The primary truth that the virtue of gratitude suggests concerning the human being in the world is the ability to transcend one's state and relate to existence beyond ourselves. If we are grateful for something we have received and grateful for life—also a gift!—then we are grateful to and for the givers, both human and, well, more than human, much more. If a story imparts wisdom that directs us toward truth, we certainly have a good deal to be grateful for. But can we be grateful in spite of the great costs of that gift? That is far from a banal question, with no straightforward answer. We might also recall the related problem of forgiving grievous harms inflicted by enemies brought up in our discussion of Wajda's *Katyń*. There

is much we must complete on that pilgrimage toward truth by ourselves despite the help we receive. When we are strengthened at some point, however, it is necessary to move beyond ourselves to find further meaning in broader truths that direct us toward others.

<center>*       *       *</center>

Gardner wisely suggests the transcendentals should form a cornerstone for our societies. As I have attempted to convey to readers, in a complementary manner truth, goodness and beauty are meta values that through their various iterations to a greater or lesser degree give meaning to life: at the individual level, the different communal levels, and beyond. Returning to Frankl's seminal ideas, without meaning power or instincts become overvalued and thus distorted— potentially also at societal levels. We seem to see something along these lines occurring in contemporary Western societies, and outside of them in some national communities, to varying degrees and in varying manners, sometimes quite disturbingly so. And things like the coronavirus pandemic prove that even at present developed countries can be exposed to matters virtually beyond their control, affecting seminal matters like a sense of security. Such a list can be extended indefinitely.

Nevertheless, with all this in mind through their potentially fundamental impact on both the personal and broadest communal levels the transcendentals are virtues that at some level serve the person and societies to move beyond many of the axiological hurdles that seem so pervasive in today's world, for those with their minds and hearts open enough to discern them in their diverse guises and iterations. Not to mention some manner of rest on the pilgrimage that these meta values help us attain is our personal version of the good life, but our journey does not stop there, as important as such a port of call happens to be. As the ancients were aware and history demonstrates, the good life may require living in virtue, but it is also dependent on the slings and arrows of outrageous fortune—to paraphrase a certain bard. Yet according to Frankl meaning can be found in the most seemingly adverse circumstances. In his "Experiences in a Concentration Camp," for instance, he writes about how camp prisoners even could gain hope from the beauty of a sunset or the sound of birds singing.[59] And where there is meaning, even if metaphorically speaking we are tenuously out at sea for some time, the transcendentals not rarely play their part in keeping us afloat, and at times do much more. But that is largely part of another story, that some would say leads us to the true source of the transcendentals.

# Notes

## Introduction

1 V.S. Naipaul, "Our Universal Civilization," in Naipaul, *The Writer and the World: Essays*, ed. Pankaj Mishra (New York: Alfred Knopf, 2002), 517.

2 Quoted in Peter Gomes, *The Good Life: Truths that Last in Times of Need* (New York: Harper Collins, 2002), 152.

3 Richard Cocks, "Beauty, Truth, and the Creative Act," *Voeglin View*, April 2, 2020, retrieved from: https://voegelinview.com/beauty-truth-and-the-creative-act/.

4 Alice M. Ramos, *Dynamic Transcendentals: Truth, Goodness, and Beauty from a Thomistic Perspective* (Washington, DC: The Catholic University of America Press, 2012).

5 Robert Royal, *The God that Did Not Fail: How Religion Built and Sustains the West* (New York: Encounter Books, 2006), 254.

6 Howard Gardner, *Truth, Beauty, and Goodness Reframed: Educating for the Virtues in the Age of Truthiness and Twitter* (New York: Basic Books, 2011), 7.

7 See, for instance, the discussion by Mark Bauerlein in "Truth, Reading, Decadence," *First Things*, June 2021, retrieved: https://www.firstthings.com/article/2021/06/truth-reading-decadence.

## Chapter 1 Between High Art and Popular Culture: Beauty Where Art Thou?

1 Guido Mina di Sospiro, "How the Most Musical Century in the History of Western Civilization Came About," *New English Review*, August 2020, retrieved from: https://www.newenglishreview.org/custpage.cfm?frm=190157&sec_id=190157.

2 Martha Bayles, *Hole in Our Soul: The Loss of Beauty & Meaning in American Popular Music* (Chicago: The University of Chicago Press, 1996), 187.

3 Vladimir Soloviev, *The Heart of Reality: Essays on Beauty, Love, and Ethics by V.S. Soloviev*, edited and translated by Vladimir Wozniuk (South Bend, IN: University of Notre Dame Press, 2020), p. 16.

4 Cocks, "Beauty, Truth, and the Creative Act."

5 William Sweet, "Jacques Maritain," *Stanford Encyclopedia of Philosophy*, Summer 2019, retrieved: https://plato.stanford.edu/entries/maritain/.

6 Julian Spalding, *The Art of Wonder: A History of Seeing* (Munich, London and New York: Prestel, 2005), 7.

7   Joseph Kupfer, *Visions of Virtue in Popular Film* (Bouldor, Colorado: Westview Press, 1999), 35–60. In his film analysis Kupfer applies virtue ethics introduced to moral philosophy by Alisdair MacIntyre.

8   See, for instance, Randall Stevens, *The Devil's Music: How Christians Inspired, Condemned, and Embraced Rock 'n' Roll* (Cambridge, Mass: Harvard University Press, 2018).

9   Walter Everett, *The Beatles as Musicians: Revolver through the Anthology* (New York and Oxford: Oxford University Press, 1999), 89.

10  Byung-Chuk Han, *The Disappearance of Rituals: A Topology of the Present*, trans. Daniel Steuer (Cambridge, UK: Polity Press, 2020), 25.

11  For a discussion of sex in rock, see Bayles, *Hole in Our Soul*, 191, passim.

12  Bayles, 156.

13  In his book on the event Neil Miniturn even counts the film with Scorsese's touch as more important than the concert itself: see his *The Last Waltz of the Band*. 'CMS Sourcebooks in American Music' No. 2, ed. Michael J Budds (Hillsdale, NY: Pendragon Press, 2005). Certainly, the audiovisual recording surpasses mere audio recordings, doing greater justice to the crucial element of performance in a concert.

14  A number of available versions of this number, for instance on DVD or YouTube, have unfortunately edited out this exclamation.

15  Mary Nichols, "A Defense of Popular Culture," *Academic Questions* 13, No. 1 (Winter 1999/2000): 76.

16  Ibid., 78.

17  Ibid., 76.

18  Ted Gioia, *Love Songs: The Hidden History* (Oxford: Oxford University Press, 2015), xii.

19  Remi Brague, *The Kingdom of Man: Genesis and Failure of the Modern Project*, trans. Paul Seaton (University of Notre Dame Press, 2018), 215.

20  Nancy McDermott, "It's Still a Wonderful Life," *Spiked-Online*, December 21, 2020, retrieved from: https://www.spiked-online.com/2020/12/21/its-still-a-wonderful-life/.

21  See, for instance, Abigail Harrington, "Atomized Moms," *First Things*, July 29, 2021, retrieved from: https://www.firstthings.com/web-exclusives/2021/07/atomized-moms.

22  See Robert Putnam, *Bowling Alone: The Collapse and Revival of American Community* (New York: Simon & Schuster, 2000).

23  This sub-plot in the film, albeit superlatively performed by the actors, is the least convincing since it is understandable that the father might be in despair once his wife dies in an accident while he is driving but it is unclear why should he end up abandoning the son that has survived.

24  Jaroslav Pelikan, *Mary Through the Centuries: Her Place in the History of Culture* (New Haven: Yale University Press, 1996), 78–9.

25  See Stanisław Chojnacki, *Major Themes in Ethiopian Painting: Indigenous Developments, the Influence of Foreign Models and Their Adaptation from the 13th to the 19th Century* (Wiesbaden: F. Steiner, 1983).
26  See the illustration in Pelikan, *Mary Through the Centuries*, viii.
27  Ted Gioia, "Face the music," *The Smart Set*, October 21, 2015, retrieved from https://thesmartset.com/FACE-THE-MUSIC/.
28  See the discussion in Adrian Thomas, *Górecki*, "Oxford Studies of Composers" (Oxford: Clarendon Press, 1997), 81–94.
29  Anna Maria Harley, "Górecki and the Paradigm of the 'Maternal,'" *Musical Quarterly* 82, 1 (1998): 105.
30  Ibid., 124.
31  Andrew Greeley, *The Catholic Imagination* (Berkeley: University of California Press, 2000), 77.
32  Han, *The Disappearance of Rituals*, 1.
33  Peter Gomes, *The Good Life: Truths That Last in Times of Need* (New York: Harper Collins, 2003), 137.
34  Tymothy Snyder, "Memory of sovereignty and sovereignty of memory: Poland, Lithuania and Ukraine, 1939–1999," in *Memory and Power in Post-War Europe: Studies in the Presence of the Past*, ed. Jan Werner Muller (Cambridge: Cambridge University Press, 2002), 39.
35  Andrzej Morka, *Doświadczenia Boga w Gułagu* (Sandomierz: Wydawnictwo Diecezjalne w Sandomierzu, 2007), 177.
36  Gardner, *Truth, Beauty, and Goodness Reframed*, 93.
37  Ramos, *Dynamic Transcendentals*, 8.
38  Mieczysław Porębski quoted in Krystyna Czerni, *Nowosielski—Sacral Art: Podlasie, Warmia and Mazury, Lublin* (Białystok: Museum of Podlasie in Białystok, 2019), 17.
39  Quoted in Czerni, *Nowosielski—Sacral Art*, 10.
40  Quoted in Czerni, *Nowosielski—Sacral Art*, 305.
41  Quoted in Czerni, *Nowosielski—Sacral Art*, 314.
42  Jakub Turbas, *Ukryte piękno. Architektura współczesnych kościołów* (Warsaw: Biblioteka Więzi, 2019), 100.
43  Greeley, *The Catholic Imagination*, 71.
44  Quoted from Norman Davies, *God's Playground: A History of Poland*, Vol. 1, *The Origins to 1795* (Oxford and New York: Oxford University Press, 2005), 96.

## Chapter 2  The National Community and the Common Good

1  Charles Taylor, *The Ethics of Authenticity* (Cambridge, Mass.: Harvard University Press, 1992), 29.

2 Byung-Chuk Han, *The Disappearance of Rituals: A Topology of the Present*, trans. Daniel Steuer (Cambridge, UK: Polity Press, 2020), 17.

3 See, e.g., George Weigel, *The Final Revolution: The Resistance Church and the Collapse of Communism* (Oxford: Oxford University Press, 1992).

4 Han, *The Disappearance of Rituals*, 34.

5 Gerard Delanty, *The European Heritage: A Critical Re-Interpretation* (London and New York: Routledge, 2018), 45.

6 Michał Gierycz, *Europejski spór o człowieka: Studium z antropologii politycznej* (Warsaw: Wydawnictwo Naukowe Uniwersytetu Kardynała Stefana Wyszyńskiego, 2017).

7 For a readable account of the dispute between Augustine and Pelagius, see Alan Jacobs, *Original Sin: A Cultural History* (London: Society for Promoting Christian Knowledge, 2008), 47–54.

8 John Paul II, *Memory and Identity: Conversations at the Dawn of a Millennium* (New York: Rizzoli, 2005), 87.

9 Alasdair MacIntyre, "Is Patriotism a Virtue?" The Lindley Lecture, The University of Kansas, 1984, 12–13. Retrieved from: https://mirror.explodie. org/Is Patriotism a Virtue-1984.pdf.

10 Quoted by Fr Maciej Zięba, "Karykatura sporu cywilizacyjnego," *Rzeczypospolita Plus Minus*, August 22–23, 2020, 7.

11 Yoram Hazony, *The Virtue of Nationalism* (New York: Basic Books, 2018), 11.

12 Yael Tamir, *Why Nationalism?* (Princeton: Princeton University Press, 2019), 181.

13 Quoted in Rupert Shortt, *Does Religion Do More Harm Than Good?* (London: Society for Promoting Christian Knowledge, 2019), 37. See also Jonathan Sacks, *Morality: Restoring the Common Good in Divided Times* (New York: Basic Books, 2020).

14 Ronald Inglehart, "Giving Up on God: The Global Decline of Religion," *Foreign Affairs*, September/October 2020, retrieved from: https://www.foreignaffairs.com/articles/world/2020-08-11/religion-giving-god.

15 See Michael J. Sandel, *The Tyranny of Merit: What's Become of the Common Good?* (London: Allen Lane, 2020).

16 Han, *The Disappearance of Rituals*, vi.

17 Jarosłwa Flis, "Niewierzący nienawidzą bardziej," interviewed by Eliza Olczyk, *Rzeczpospolita: Plus/Minus*, January 9–10, 2021, 25.

18 Mirosława Grabowska, *Bóg a sprawa Polska. Poza granicami teorii sekularyzacji* (Warsaw: Wydawnictwo Naukowe Scholar, 2018).

19 See Carolyn Moynihan, "A Nordic Paradox: higher gender equality, more partner violence," *Mercatornet.com*, May 28, 2019, retrieved from: https:// mercatornet.com/a-nordic-paradox-higher-gender-equality-more-partner-violence/24369/.

20  Quoted in Christopher Garbowski, "Principles of Social Harmony and the Wedding of Progress and Tradition," *The Polish Review* 64, No. 1 (2019), 68.

21  Geoffrey Hosking, *Trust: A History* (Oxford and New York: Oxford University Press, 2014), 194.

22  Paddy Scannell, *Love and Communication* (Cambridge, UK: Polity Press, 2021), 14.

23  Jakub Grygiel, "The return of Europe's nation states," *Foreign Affairs* 95, 5 (2016): 99.

24  Ryszard Legutko, *The Demon in Democracy: Totalitarian Temptations in Free Societies* (New York: Encounter Books, 2016), 41.

25  See Sandel, *The Tyranny of Merit*, 29.

26  See Christopher Garbowski, "The Polish Debate on the House of European History," *The Polish Review* 65, No. 4 (2020): 60–70.

27  Michal Kuź, "Globalism and Localism in the Perspective of Polish Politics," *The Warsaw Institute Review*, June 27, 2017, retrieved from: https://warsaw-institute.org/globalism-and-localism-in-the-perspective-of-polish-politics/.

28  Peter Hitchens, *The Rage against God* (London: Continuum, 2010), 59–60.

29  Marcin Piatkowski, *Europe's Growth Champion: Insights from the Economic Rise of Poland* (Oxford: Oxford University Press, 2018).

30  Pawel Gierech, "Kilka uwag o polskiej młodzieży początku XXI wieku," *Teologia Polityczna*, No. 5 (Summer 2009/ Fall 2010): 229.

31  Mary Eberstadt, *How the West Really Lost God: A New Theory of Secularization* (West Conshohocken, PA: Templeton Press, 2013).

32  Sandel, *The Tyranny of Merit*, 29.

33  Janusz Czapiński, "Państwo w ruinie, a Polacy szczęśliwi," *Rzeczpospolita Plus Minus*, October 10, 2018.

34  Pascal Bruckner, *The Tyranny of Guilt: An Essay on Western Masochism* (Princeton: Princeton University Press, 2010), 36.

35  W. Julian Korab-Karpowicz, *Tractatus Politico-Philosophicus / Traktat polityczno-filozoficzny* (Kęty: Marek Derewiecki, 2015), 204.

36  The Paris Statement: A Europe We Can Believe In, 2017, retrieved from https://thetrueeurope.eu/a-europe-we-can-believe-in/. The paragraphs of the statement are numbered and in further quotes these numbers will direct the readers.

37  This is clear in Article 3b of the treaty. See Anthony Teasdale, "Subsidiarity in Post-Maastrich Europe," *Political Quarterly* 64, No. 2 (1993): 187–197.

38  Frank Furedi, *Populism and the European Culture Wars: The Conflict of Values between Hungary and the EU* (London and New York: Routledge, 2017), 115–16.

39  Douglas Murray, *The Strange Death of Europe: Immigration, Identity, Islam* (London: Bloomsbury, 2017), 258.

40  See Viktor E. Frankl, *Man's Search for Ultimate Meaning*, revised edition (New York: Washington Square Press, 1984).

41  Journalist Piotr Zaremba pointed out in the most recent presidential elections that religious Poles currently have a very limited choice of which party to vote for if they wish to support one that does not go against their values.

42  Tomasz Wiścicki, "Odejście Kościoła, jaki znami," *Rzeczy Wspólne* 35, No. 4 (2020): 46–55.

43  See Przemysław Urbańczyk, "Religia i religijność w czasach pierwszy Piastów," in *Religia obywatelska w Polsce. Między początkami państwowości a współczesnością*, ed. Janusz Węgrzecki (Warszawa: Wydawnictwo Naukowe UKSW, 2016), 127–144.

44  Quoted in Paweł Warchoł, *Polsko, ojczyzna moja. Twoja tożsamość wczoraj, dziś i jutro* (Pelpin: Wydawnictwo Bernardinium, 2017), 26.

45  Marek Cichocki and Dariusz Karłowicz, "Galeria Polaków," *Teologia Polityczna*, No. 9 (2016), 7.

46  Ibid., 8.

47  Ibid., 9.

48  Selim Chazbijewicz, interviewed by Łukasz Adamski, "Islam musi się zmienić," *Fronda* 53 (2009): 246.

49  For a good idea of the Tatar life in Poland, especially from the perspective of rituals, see Barbara Pawlic-Miskiewicz, *Performance of Identity of Polish Tatars: From Religious Holidays to Everyday Rituals* (Berlin: Peter Lang, 2018).

50  Christopher Garbowski, "Polin: From a 'Here You Shall Rest' Covenant to Creation of a Polish Jewish History Museum: An interview with Barbara Kirshenblatt-Gimblett," *The Polish Review* 61, No. 2 (2016): 3–17.

51  See his account of Catholic Jewish dialogue in post-war Poland in: Stanisław Krajewski, *Poland and the Jews: Reflections of a Polish Polish Jew* (Kraków: Austeria, 2005), 203–236.

52  Robert Mazurek, "Wygodna pałka antysemityzmu," interview with Paweł Jędrzejewski, *Dziennik Gazeta Prawna*, January 25–27, 2019, 44–43.

53  Paweł Jędrzejewski, "Czy niemieckie zbrodnie będą jeszcze pamiętane w ich setną rocznicę?" *Salon24*, July 14, 2021, retrieved: https://www.salon24.pl/u/jedrzejewski/1150257,czy-niemieckie-zbrodnie-beda-jeszcze-pamietane-w-ich-setna-rocznice.

54  Paweł Jędrzejewski, "Rabini i Księża, stawajcie w obronie bitych a nie tych, którzy biją," *Salon24*, August 18, 2020, retrieved: https://www.salon24.pl/u/jedrzejewski/1071580,rabini-i-ksieza-stawajcie-w-obronie-bitych-a-nie-tych-ktorzy-bija.

55  Paweł Jędrzejewski, "Centrum Simona Wiesenthala publikuje doroczną listę 'antysemickich wydarzeń.' Nietrudno zgadnąć, że o Polsce nie ma tam mowy," *Forum Żydów Polskich*, nd., retrieved from https://forumzydowpolskichonline.org/2019/12/22/1058/.

56  For an overview of current Jewish life in Poland, among other matter, see Feliks Tych and Monika Adamczyk-Garbowska, eds. *Jewish Presence in Absence: The Aftermath of the Holocaust in Poland, 1944–2010*, trans. Grzegorz Dąbkowski and Jessica Taylor-Kucica (Jerusalem: Yad Vashem, 2014).

57  Although the number of Kurds is not great in Poland—like other groups they also have difficulty gaining permanent residence—Poland has quite am effective Kurdish studies center in Krakow, responsible for the book *Rediscovering Kurdistan's Cultures and Identities: The Call of the Cricket*, edited by Joanna Bocheńska (Cham, Switzerland: Palgrave, 2018).

58  James Q. Wilson makes some interesting comments on Putnam's study of multi-cultural neighborhoods. See Wilson, "Bowling with Others," *Commentary*, October 2007, 30–33.

59  Luma Simms, "Immigrants, assimilation and religion," *Public Discourse*, March 10, 2016, retrieved from https://www.thepublicdiscourse.com/2016/03/16421/.

60  Marek Cichocki, *Północ i Południe: Teksty o polskiej kulturze i historii* (Warsaw: Teologia Polityczna, 2018).

61  Douglas Murray, *The Madness of Crowds: Gender, Race and Identity* (London, et al.: Bloomsbury, 2019), 176–83.

62  Ramos, *Dynamic Transcendentals*, 106–107.

63  Armond White, "Polish Oscar Nominee *Corpus Christi* Preaches Forgiveness," *National Review*, February 20, 2020, retrieved from: https://www.nationalreview.com/2020/02/movie-review-corpus-christi-takes-morality-seriously/

64  See, e.g. Joseph Kupfer, *Feminist Ethics in Film: Reconfiguring Care through Cinema* (Bristol, UK: Intellect Books, 2012), 81–92.

65  Frank Furedi, *How Fear Works: Culture of Fear in the 21$^{st}$ Century* (London: Bloomsbury, 2019), 216–19.

66  See also Elizabeth Fox-Genovese, *Feminism Without Illusions: A Critique of Individualism* (Chapel Hill: The University of North Carolina Press, 1991), 7.

67  Han, *The Disappearance of Rituals*, 39.

68  James V. Schall, *The Sum Total of Human Happiness* (South Bend, Il: St. Augustine's Press, 2006), 150–51.

69  Dariusz Karłowicz, "Podróż Trzech Króli" [The journey of the Three Kings], *Teologia Polityczna*, January 6, 2012, retrieved from: https://teologiapolityczna.pl/podroz-trzech-kroli-4.

# Chapter 3  Truth and Meaning:
##           A Pilgrimage Toward Wisdom

1  Gardner, *Truth, Beauty, and Goodness Reframed*, 7.

2  Dr Hannah Fry and Dr Thomas Oleron Evans, *The Indisputable Existence of Santa Claus: The Mathematics of Christmas* (London: Transworld Publishers, 2016).

3  Walter Ong, *Interfaces of the Word: Studies in the Evolution of Consciousness and Culture* (Cornell University Press, 1977), 337.

4  Arthur Ocean Waskow and Phyllis Ocean Berman, *A Time for Every Purpose Under Heaven: The Jewish Life Spiral as a Spiritual Path* (New York: Farrar, Straus and Giroux, 2002), xxix.

5  Robert P. George, "Solzhenitsyn's Prophesy," *First Things*, November 6, 2018, retrieved from: https://www.firstthings.com/web-exclusives/2018/06/solzhenitsyns-prophecy.

6  See Stanisław Żerko, "Poland and Germany: Reparations," *The Polish Quarterly of International Affairs* 26, No. 4 (2017): 96–107.

7  See Richard Butterwick, *The Constitution of 3 May 1791: Testament of the Polish-Lithuanian Commonwealth* (Warsaw: Polish History Museum, 2021). Available online in PDF format.

8  Józef Tischner, *The Spirit of Solidarity*, trans. Marek Zaleski and Benjamin Fiore, S.J. (San Francisco: Harper & Row, 1984), 93, 95.

9  Maciej Zięba, OP. *Pontyfikat na czasu zamętu. Jan Paweł II wobec wyznań Kościoła i świata* (Poznań: Wydawnictwo W drodze, 2020), 107.

10 Han, *The Disappearance of Rituals*, 37.

11 Ewa Thompson, "Solidarność w Polsce vs. Maj 1968 w Francji," *Teologia Polityczna*, January 19, 2021, retrieved from: https://teologiapolityczna.pl/ewa-thompson-solidarnosc-1980-w-polsce-vs-maj-1968-we-francji-felie ton-1.

12 Brian Porter-Szűcs, *Poland in the Modern World: Beyond Martyrdom* (Malden, MA: Wiley Blackwell, 2014), 3.

13 David Bond, "Queen and Donald Trump lead D-Day anniversary tributes," *Financial Times*, June 5, 2019, retrieved from: https://www.ft.com/content/84280f6e-879f-11e9-a028-86cea8523dc2. See also Jan Hudzik, "Reflections on German and Polish Historical Policies of Holocaust Memory," *The Polish Review* 65, No. 4 (2020): 36–59.

14 James Kirchick, *The End of Europe: Dictators, Demagogues, and the Coming Dark Age* (New Haven: Yale University Press, 2017), 88–89. For a German perspective sensitive to Polish fears, see: Reinhard Butikofer, "Germany cannot disregard Poland's objections to Nord Stream 2," *Wszystko Co Najważniejsze*, August 4, 2021, retrieved from: https://wszystkoconajwazniejsze.pl/reinhard-b utikofer-germany-cannot-disregard-polands-objections-to-nord-stream-2/.

15 Quoted in Murray, *The Strange Death of Europe*, 228.

16 One of the sources newsagents from abroad turn to for information about what is going on in Poland is the newspaper *Gazeta Wyborcza*. For an evaluation of the consequences of this, see Agnieszka Kolakowska, "Poland's

Grand Panjandrum: Review Essay," *Standpoint Magazine*, October 2014, retrieved from: https://standpointmag.co.uk/books-october-14-polands-grand-panjandrum-agnieszka-kolakowska-adam-michnik/.

17  A rather against the grain discussion of the issues involved that is fairly sympathetic for East Central Europe as a whole is found in Frank Furedi, *Populism and the European Culture Wars: The Conflict of Values between Hungary and the EU* (London and New York: Routledge, 2017). See also Rod Dreher's more recent opinion piece: "EU big lies about Hungary's LGBT law," *The American Conservative*, June 23, 2021, retrieved from: https://www.theamericanconservative.com/dreher/von-der-leyen-lies-about-hungary-lgbt-law/.

18  See Artur Wołek, *Słabe państwo* (Kraków: Ośrodek Myśli Politycznej; Warszawa: Instytut Studiów Politycznych PAN, 2012).

19  Jan Rokita, "Fałszywa historia jako mistrzyni fałszywej polityki," *Teologia Polityczna*, June 13, 2021, retrieved from: https://teologiapolityczna.pl/jan-rokita-falszywa-historia-jako-mistrzyni-falszywej-polityki-felieton.

20  Amartya Sen, "Democracy as a Universal Value," *Journal of Democracy* 10, No. 3 (1999): 3.

21  Niall Ferguson, "The China model: why is the West imitating Beijing?," *The Spectator*, May 8, 2021, retrieved from: https://www.spectator.co.uk/article/the-china-model-why-is-the-west-imitating-beijing.

22  Quoted from Observatory on Intolerance and Discrimination Against Christians in Europe, *Report 2019*, ed. Ellen Fantini (Vienna, 2019), 6.

23  For an overview of recent literature on the topic, see Mathew Frank, "Bookshelf: Essential Reading on Religious Freedom," *Public Discourse*, June 4, 2021, retrieved from: https://www.thepublicdiscourse.com/2021/06/76161/.

24  See George Weigel, "Justin Trudeau and the Dictatorship of Relativism," *First Things*, May 32, 2018, retrieved from: https://www.firstthings.com/web-exclusives/2018/05/justin-trudeau-and-the-dictatorship-of-relativism#print.

25  George, "Solzhenitsyn's Prophesy."

26  Jan Rokita, "Bóg, naród i euro," *Wszystko co Najważniejsze*, June 21, 2019, retrieved from: https://wszystkoconajwazniejsze.pl/jan-rokita-bog-narod-i-euro/.

27  Filip Mazurczak, "Poland and Abortion," *The Catholic World Report*, February 16, 2021, retrieved from: https://www.catholicworldreport.com/2021/02/16/poland-and-abortion/.

28  Anthony Esolen, "How the Church Has Changed the World: Be Not Afraid." *Magnificat* (May, 2020).

29  Elizabeth Fox-Genovese, "A Pro-Woman Pope," *Catholic Education Resource Center*, nd., retrieved from: https://www.catholiceducation.org/en/controversy/feminism/a-pro-woman-pope.html.

30  Quoted in Rodney Stark, *For the Glory of God: How Monotheism Led to Reformation, Science, Witch-Hunts, and the End of Slavery* (Princeton: NJ: Princeton University Press, 2003), 148.

31  Fittingly, this was the first Polish painting ever exhibited at London's National Gallery. See Brooke Weichel, "To the Heavens: First Polish Painting at London's National Gallery," *Culture.pl*, June 21, 2021, retrieved from https://culture.pl/en/article/to-the-heavens-first-polish-painting-at-londons-national-gallery.

32  The Reformation complicated the relationship of faith to reason which was a key to the development of science. But is should be remembered, among other things, most of the Ivy League colleges established in the United States has a Protestant religious foundation, e.g. Harvard by the Puritans, and the liberal arts were part of the program practically from the start. See Anthony Chiorazzi, "Harvard's religious past," *Harvard Gazette,* October 20, 2016, retrieved from: https://news.harvard.edu/gazette/story/2016/10/harvards-religious-past/.

33  Remi Brague, *The Kingdom of Man: Genesis of the Failure of the Modern Project*, trans. Paul Seaton (Notre Dame, IN: University of Notre Dame Press, 2018), 53, 58.

34  J.R.R. Tolkien, *The Letters of JRR Tolkien*, edited by Humphrey Carpenter (London: Harper Collins, 1990), 145–46.

35  C. John Sommerville, *The Decline of the Secular University* (Oxford: Oxford University Press, 2006), 23.

36  John Searle, "Politics and the Humanities," *Academic Questions* 12, no. 4 (1991): 51.

37  Czesław Miłosz, *Visions from San Francisco Bay*, trans. Richard Lourie (New York: Farrar, Straus, Giroux, 1988), 191.

38  Sommerville, *The Decline of the Secular University*, 31–2.

39  Quoted in Ibid., 34.

40  Quoted in Valdimir Tismananeanu, *The Devil in History: Communism, Fascism, and Some Lessons of the Twentieth Century* (Berkeley: University of California Press, 2011), 3.

41  See, for instance, Rev. Jacek Grzybowski describes the attitude at his own Cardinal Stefan Wyszyński University in Warsaw in his: *Szukając światła w nocy świata. Rozważania o religii, kulturze i polityce* (Kielce: Jedność, 2018), 140–41.

42  As far as I know Gary Saul Morson was the first to use this term.

43  C. S. Lewis, *Mere Christianity* (New York: HarperCollins, 2009), 28.

44  Sommerville, *The Decline of the Secular University*, 37–38.

45  David Carr, *Time, Narrative, and History* (Bloomington, IN: Indiana University Press, 1991), 177.

46  Michael Steinlauf, *The Bondage of the Dead: Poland and the Memory of the Holocaust* (Syracuse, NY: Syracuse University Press, 1997), 139.

47  Antony Polonsky, for instance, suggests that the presence of a substantial
    number of communists of Jewish origin in significant positions in the se-
    curity apparatus of the early post-war regime in Poland "has to be seen as a
    consequence of Stalin's deep distrust of the Poles." See Polonsky, *The Jews of
    Poland and Russia: A Short History* (Oxford and Portland, OR: The Littman
    Library of Jewish Civilization, 2013), 397.

48  Among the more controversial topics surrounding Polish complicity in the
    death of a number of their Jewish neighbors during the war is the Jedwabne
    massacre. For a summary of the debate, see *The Neighbors Respond: The
    Controversy over the Jedwabne Massacre in Poland*, edited by Antony Polonsky
    and Joanna Michlic (Princeton: Princeton University Press, 2004).

49  Halik Kochanski, *The Eagle Unbowed: Poland and the Poles in the Second
    World War* (London: Allen Lane, 2012), 591.

50  For a good discussion of this problem of heroism, see Peter Gibbon, *A Call to
    Heroism: Renewing America's Vision of Greatness* (New York: Atlantic Monthly
    Press, 2002).

51  This seems to be the problem with some of the historians connected to the
    Polish Center for Holocaust Studies, in part as a reaction to the critical re-
    ception of the work on the part of uncritical patriots—which is simply a
    more obvious problem, but does not excuse going to the other extreme.
    See Jan Hudzik, "Reflections on German and Polish Historical Policies of
    Holocaust Memory," *The Polish Review* 65, No. 4 (2020): 54–58; see also Paweł
    Jędrzejewski, "Jak Barbara Engelking i Jan Grabowski zbiorą wypuszczone
    na wiatr pierze?" *Salon24*, February 10, 2021, retrieved from https://www.
    salon24.pl/u/jedrzejewski/1111972,jak-barbara-engelking-i-jan-grabowski-
    zbiora-wypuszczone-na-wiatr-pierze.

52  Cf. Furedi, *Populism and the European Culture Wars*, 82, 84.

53  Ewa Thompson, "Postmodernism and European Memory," *Modern Age*,
    Spring 2009, 112.

54  Ewa Thompson, Review of *Teby-Smoleńsk-Warszawa* (Warszawa: Teologia
    Polityczna Press, 2020), *The Polish Review*, in print.

55  Brague, *The Kingdom of Man*, 90.

56  Sommerville, *The Decline of the Secular University*, 43.

57  Kupfer, *Visions of Virtue in Popular Film*, 31.

58  Marjorie Suchocki, *Through a Lens Darkly: Tracing Redemption in Film*
    (Eugene, OR: Cascade Books, 2015), 48.

59  Frankl, *Man's Search for Meaning*, 19–116.

# Select Bibliography

Bayles, Martha. *Hole in Our Soul: The Loss of Beauty & Meaning in American Popular Music*. Chicago: The University of Chicago Press, 1996.

Brague, Remi. *The Kingdom of Man: Genesis and Failure of the Modern Project*, translated by Paul Seaton. South Bend, IN: University of Notre Dame Press, 2018.

Bruckner, Pascal. *The Tyranny of Guilt: An Essay on Western Masochism*. Princeton: Princeton University Press, 2010.

Carr, David. *Time, Narrative, and History*. Bloomington, IN: Indiana University Press, 1986.

Cocks, Richard. "Beauty, Truth, and the Creative Act." *Voeglin View*, April 2, 2020. Retrieved from: https://voegelinview.com/beauty-truth-and-the-creative-act/

Czerni, Krystyna. *Nowosielski—Sacral Art: Podlasie, Warmia and Mazury, Lublin*. Białystok: Museum of Podlasie in Białystok, 2019.

Delanty, Gerard. *The European Heritage: A Critical Re-Interpretation*. London and New York: Routledge, 2018.

Eberstadt, Mary. *How the West Really Lost God: A New Theory of Secularization*. West Conshohocken, PA: Templeton Press, 2013.

Fox-Genovese, Elizabeth. *Feminism Without Illusions: A Critique of Individualism*. Chapel Hill: The University of North Carolina Press, 1991.

Frank, Mathew. "Bookshelf: Essential Reading on Religious Freedom." *Public Discourse*, June 4, 2021. Retrieved from: https://www.thepublicdiscourse.com/2021/06/76161/.

Frankl, Viktor E. *Man's Search for Ultimate Meaning*, revised edition. New York: Washington Square Press, 1984.

Ferguson, Niall. "The China model: why is the West imitating Beijing?" *The Spectator*, May 8, 2021. Retrieved: https://www.spectator.co.uk/article/the-china-model-why-is-the-west-imitating-beijing.

Furedi, Frank. *How Fear Works: Culture of Fear in the 21st Century*. London: Bloomsbury, 2019.

Furedi, Frank. *Populism and the European Culture Wars: The Conflict of Values between Hungary and the EU*. London and New York: Routledge, 2017.

Gardner, Howard. *Truth, Beauty, and Goodness Reframed: Educating for the Virtues in the Age of Truthiness and Twitter*. New York: Basic Books, 2011.

Gibbon, Peter. *A Call to Heroism: Renewing America's Vision of Greatness*. New York: Atlantic Monthly Press, 2002.

Gioia, Ted. *Love Songs: The Hidden History*. Oxford: Oxford University Press, 2015.

Gomes, Peter. *The Good Life: Truths That Last in Times of Need*. New York: Harper Collins, 2003.

Greeley, Andrew. *The Catholic Imagination*. Berkeley: University of California Press, 2000.

Grygiel, Jakub. "The return of Europe's nation states." *Foreign Affairs* 95, No. 5 (2016): 94–101.

Han, Byung-Chuk. *The Disappearance of Rituals: A Topology of the Present*, translated by Daniel Steuer. Cambridge, UK: Polity Press, 2020.

Hazony, Yoram. *The Virtue of Nationalism*. New York: Basic Books, 2018.

Hosking, Geoffrey. *Trust: A History*. Oxford and New York: Oxford University Press, 2014.

Hudzik, Jan. "Reflections on German and Polish Historical Policies of Holocaust Memory." *The Polish Review* 65, No. 4 (2020): 36–59.

Kirchick, James. *The End of Europe: Dictators, Demagogues, and the Coming Dark Age*. New Haven: Yale University Press, 2017.

Kochanski, Halik. *The Eagle Unbowed: Poland and the Poles in the Second World War*. London: Allen Lane, 2012.

Korab-Karpowicz, W. Julian. *Tractatus Politico-Philosophicus: New Directions for the Future Development of Humankind*. New York and London: Routledge, 2012.

Kupfer, Joseph. *Feminist Ethics in Film: Reconfiguring Care through Cinema*. Bristol, UK: Intellect Books, 2012.

Kupfer, Joseph. *Visions of Virtue in Popular Film*. Boulder, Colorado: Westview Press, 1999.

Kuź, Michal. "Globalism and Localism in the Perspective of Polish Politics." *The Warsaw Institute Review*, June 27, 2017. Retrieved: https://warsawinstitute.org/globalism-and-localism-in-the-perspective-of-polish-politics/.

Jacobs, Alan. *Original Sin: A Cultural History*. London: Society for Promoting Christian Knowledge, 2008.

John Paul II, *Memory and Identity: Conversations at the Dawn of a Millennium*. New York: Rizzoli, 2005.

Legutko, Ryszard. *The Demon in Democracy: Totalitarian Temptations in Free Societies*. New York: Encounter Books, 2016.

MacIntyre, Alasdair. "Is Patriotism a Virtue?" The Lindley Lecture, The University of Kansas, 1984. Retrieved from: https://mirror.explodie.org/Is Patriotism a Virtue-1984.pdf.

Miłosz, Czesław. *Visions from San Francisco Bay*, translated by Richard Lourie. New York: Farrar, Straus, Giroux, 1988.

Murray, Douglas. *The Strange Death of Europe: Immigration, Identity, Islam*. London: Bloomsbury, 2017.

Naipaul, V. S. "Our Universal Civilization." In Naipaul, *The Writer and the World: Essays*, edited by Pankaj Mishra. New York: Alfred Knopf, 2002.

Nichols, Mary P. "A Defense of Popular Culture." *Academic Questions* 13, No. 1 (Winter 1999/2000): 73–78.

Ong, Walter. *Interfaces of the Word: Studies in the Evolution of Consciousness and Culture*. Cornell University Press, 1977.

*The Paris Statement: A Europe We Can Believe In*. 2017. Retrieved: https://thetrueeurope.eu/a-europe-we-can-believe-in/.

Pelikan, Jaroslav. *Mary Through the Centuries: Her Place in the History of Culture*. New Haven: Yale University Press, 1996.

Ramos, Alice M. *Dynamic Transcendentals: Truth, Goodness, and Beauty from a Thomistic Perspective*. Washington, DC: The Catholic University of America Press, 2012.

Royal, Robert. *The God that Did Not Fail: How Religion Built and Sustains the West*. New York: Encounter Books, 2006.

Sacks, Jonathan. *Morality: Restoring the Common Good in Divided Times*. New York: Basic Books, 2020.

Sandel, Michael J. *The Tyranny of Merit: What's Become of the Common Good?* London: Allen Lane, 2020.

Scannell, Paddy. *Love and Communication*. Cambridge, UK: Polity Press, 2021.

Sen, Amartya. "Democracy as a Universal Value." *Journal of Democracy* 10, No. 3 (1999): 3–17.

Soloviev, Vladimir. *The Heart of Reality: Essays on Beauty, Love, and Ethics by V.S. Soloviev*, edited and translated by Vladimir Wozniuk. South Bend, IN: University of Notre Dame Press, 2020.

Sommerville, C. John. *The Decline of the Secular University*. Oxford: Oxford University Press, 2006.

Spalding, Julian. *The Art of Wonder: A History of Seeing*. Munich, London and New York: Prestel, 2005.

Stark, Rodney. *For the Glory of God: How Monotheism Led to Reformation, Science, Witch-Hunts, and the End of Slavery.* Princeton: NJ: Princeton University Press, 2003.

Suchocki, Marjorie. *Through a Lens Darkly: Tracing Redemption in Film.* Eugene, OR: Cascade Books, 2015.

Tamir, Yael. *Why Nationalism?* Princeton: Princeton University Press, 2019.

Taylor, Charles. *The Ethics of Authenticity.* Cambridge, Mass.: Harvard University Press, 1992.

Tischner, Józef. *The Spirit of Solidarity*, translated by Marek Zaleski and Benjamin Fiore, S.J. San Francisco: Harper & Row, 1984.

Tismananeanu, Vladimir. *The Devil in History: Communism, Fascism, and Some Lessons of the Twentieth Century.* Berkeley: University of California Press, 2011.

Tych, Feliks, and Monika Adamczyk-Garbowska, eds. *Jewish Presence in Absence: The Aftermath of the Holocaust in Poland, 1944–2010*, translated by Grzegorz Dąbkowski and Jessica Taylor-Kucica. Jerusalem: Yad Vashem, 2014.

# Index of Names

## Interdisciplinary Studies in Performance

### Edited by Mirosław Kocur

The series aims at presenting innovative cross disciplinary and intercultural research in performance practice and theory. Its mission is to expand and enrich performance studies with new research in theatre, film, dance, ritual, and art, as well as in queer and gender studies, anthropology, linguistics, archaeology, ethnography, sociology, history, media and political sciences, and even medicine and biology. The series focuses on promoting groundbreaking methodologies and new directions in studying performative culture by scrutinizing its transformative and transgressive aspects.

The series Interdisciplinary Studies in Performance publishes in English and German monographs and thematic collections of papers by scholars from Poland and from abroad.

Vol.  1   Paul Martin Langner / Agata Mirecka (Hrsg.): Tendenzen der zeitgenössischen Dramatik. 2015.

Vol.  2   Veronika Darian / Micha Braun / Jeanne Bindernagel / Mirosław Kocur (Hrsg.): Die Praxis der/des Echo. Zum Theater des Widerhalls. 2015.

Vol.  3   Magdalena Barbaruk: The Long Shadow of Don Quixote. Translated by Patrycja Poniatowska. 2015.

Vol.  4   Mirosław Kocur: On the Origins of Theater. Translated by David Malcolm. 2016.

Vol.  5   Matteo Bonfitto: The Kinetics of the Invisible. Acting Processes in Peter Brook's Theatre. 2016.

Vol.  6   Graziela Rodrigues: Dancer – Researcher – Performer: A Learning Process. 2016.

Vol.  7   Teresa Pękala (ed.): Witkacy. Logos and the Elements. Translated by Jerzy Adamko. 2017.

Vol.  8   Mirosław Kocur: The Second Birth of Theatre. Performances of Anglo-Saxon Monks. Translated by Grzegorz Czemiel. 2017.

Vol.  9   Paul Martin Langner / Agata Mirecka (Hrsg.): Raumformen in der Gegenwartsdramatik. 2017.

Vol.  10   Christopher Garbowski: Cinematic Echoes of Covenants Past and Present. National Identity in the Historical Films of Steven Spielberg and Andrzej Wajda. 2018.

Vol.  11   Mirosław Kocur: The Power of Theater. Actors and Spectators in Ancient Rome. 2018.

Vol.  12   Janina Falkowska / Krzysztof Loska (eds.): Conflict and Controversy in Small Cinemas. 2018.

Vol  13   Barbara Pawlic-Miśkiewicz: Performance of Identity of Polish Tatars. From Religious Holidays to Everyday Rituals. 2018.

Vol  14   Magdalena Zamorska: Intense Bodily Presence. Practices of Polish Butō Dancers. 2018.

Vol.  15   Iwona Grodź: Between Dream and Reality: *The Saragossa Manuscript*. An Analysis of Wojciech Jerzy Has's Movie. 2018.

Vol.  16   Joanna Miklaszewska: American Political Opera in the Twentieth Century. 2019.

Vol.  17   Masoud Najafi Ardabili: Grotowski in Iran. 2019.

Vol.  18   Sebastian Jakub Konefał: The Cinema of Iceland. Between Tradition and Liquid Modernity. 2019.

Vol.  19   Alina Borkowska-Rychlewska: Shakespeare in 19th-Century Opera. Romantic Contexts, Inspirations and References. 2019.

Vol.  20   Andrzej Dabrówka: Theater and the Sacred in the Middle Ages. 2019.

Vol.  21   Paul Martin Langner / Joanna Gospodarczyk (Hrsg.): Zur Funktion und Bedeutung des Chors im zeitgenössischen Drama und Theater. 2019.

www.peterlang.com

Printed in Great Britain
by Amazon

8f56fedb-01fa-4388-ae81-85004dc251d5R01